IMAGES
of America

CLINTON COUNTY

Mr. Updegraff,
Thank you for encouraging my professional development. It is because of your support that I was able to complete this book.

Eni M. Smith

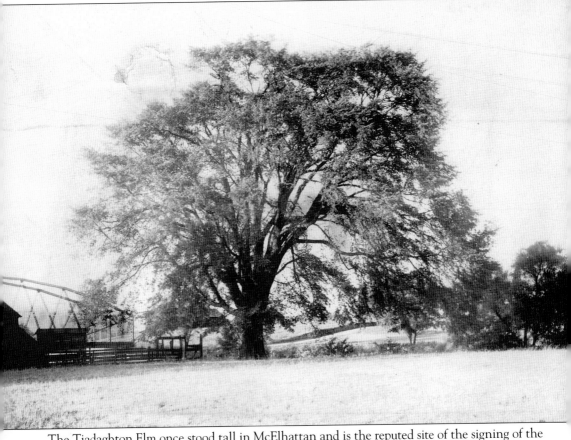

The Tiadaghton Elm once stood tall in McElhattan and is the reputed site of the signing of the Tiadaghton Declaration of Independence by the Fair Play Men, a group of settlers that had its own form of provincial government. The signing occurred on July 4, 1776, the same day the U.S. Declaration of Independence was ratified. The Tiadaghton document also was reported to have renounced allegiance to the English monarchy, although the document has never been found. (Courtesy of the Clinton County Historical Society.)

On the cover: This 1913 photograph shows a lumber crew taking a break from work near the borough of Loganton in Sugar Valley. The valley's earliest lumber mill was built in 1800 by John Kleckner, and in the 1860s, there were as many as 34 lumber mills there. Due to a lack of available waterways, mills in Sugar Valley were built close to the source of the lumber. (Courtesy of the Annie Halenbake Ross Library.)

IMAGES of America
CLINTON COUNTY

Eric M. Smith

Copyright © 2007 by Eric M. Smith
ISBN 978-0-7385-5451-8

Published by Arcadia Publishing
Charleston SC, Chicago IL, Portsmouth NH, San Francisco CA

Printed in the United States of America

Library of Congress Catalog Card Number: 2007923520

For all general information contact Arcadia Publishing at:
Telephone 843-853-2070
Fax 843-853-0044
E-mail sales@arcadiapublishing.com
For customer service and orders:
Toll-Free 1-888-313-2665

Visit us on the Internet at www.arcadiapublishing.com

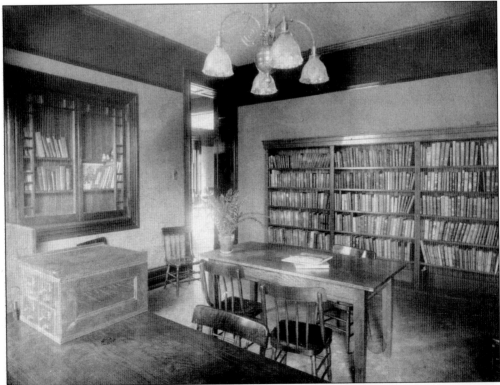

The Annie Halenbake Ross Library Pennsylvania Room is seen as it was in 1915. The Pennsylvania Room collection has grown over the years and still remains a popular destination for researchers of local and state history and family genealogy. The Annie Halenbake Ross Library is located at 232 West Main Street, Lock Haven. (Courtesy of the Annie Halenbake Ross Library.)

Contents

Acknowledgments		6
Introduction		7
1.	Founders and Foundations	9
2.	Getting There by Wagon, Boat, Train, or Automobile	17
3.	Industry and Business, Big and Small	29
4.	The Evolution of Education	61
5.	Call to Service	79
6.	Untamed Susquehanna	89
7.	Outside of Work, There Is Play	115

Acknowledgments

In every community, there are dedicated and largely unrecognized individuals who are the stewards of local history. They are the ones who often receive little thanks for their efforts in documentation and years of service.

These are people like Rosalie Long, curator of the Pennsylvania Room at the Annie Halenbake Ross Library in Lock Haven. As the writer and organizer of this book, I am extremely fortunate to have permission from the library's trustees to use this collection, which Rosalie spent decades sorting, cataloguing, and updating. These images represent the bulk of the photographs from the book because of their quality, accessibility, and documentation. Many of these photographs were donated by people who knew that they had something special in their family albums, but they also came from people like Rebecca Gross, a celebrated managing editor of the *Lock Haven Express*, and J. W. C. Floyd, an early Lock Haven–based photographer who moved to the area from Ohio.

Clinton County also is fortunate to have people like Lou Bernard, curator of the Heisey Museum in Lock Haven, who helped me delve into the collection of the Clinton County Historical Society. Lou graciously surrendered his spare time and stayed beyond the museum's hours to go through boxes of photographs and memorabilia. His willingness to help others knows no hours of operation.

There also are individuals who have a genuine love of home—people like Vickie Hibbler, a Lock Haven University employee who has fond recollections of the community of Farrandsville, which was once a hub of activity and industry. Her photographs of the Civilian Conservation Corps camp in Farrandsville are rare treasures.

And lastly, there are collections from entities that are major contributors to the community's history, such as Lock Haven University and its archive at Stevenson Library. My thanks go to Bernadette Heiney, information services technician, and Dr. Tara Fulton, dean of library and information services, for their assistance with the university's archive.

There are still many untapped wells of Clinton County photographic history that could be explored, and I wish to convey my appreciation to those stewards as well.

INTRODUCTION

It would greatly depend upon who one would ask as to when Clinton County saw its heyday, or if that day has yet to come.

For the lover of lore, that day may very well have come in 1776, when a group of individuals calling themselves the Fair Play Men is reputed to have signed its own version of a declaration of independence under the Tiadaghton Elm in McElhattan. The Fair Play Men were able to settle disputes before a provincial government was formally established in the region.

Perhaps some people would cite the incredible growth the county experienced during its lumbering days, as the fortunes of many area residents were made and the development of an infrastructure took place in the later half of the 19th century as a result. Lumbering was responsible for development of transportation and the region's railroads and was a lure for people to settle in Clinton County. Many supporting businesses cropped up during this period. And others may point to the diverse industry and business base that emerged after the end of the lumbering era in the early 1900s, as the county was home to brickmakers, furniture manufacturers, tanneries, coal and clay mining operations, and paper and printing operations.

And still, there are some who may say that day is yet to come, as the Clinton County Economic Partnership and Downtown Lock Haven both work with the municipal governments to grow Clinton County and see it develop. With First Quality Enterprises locating in Lock Haven, paper-related products are once again a main staple of production. A downtown beautification program is renewing streetscapes and facades of the county seat, and industrial parks are being developed at select locations in Clinton County.

Throughout the county's history, much has come and gone with a few hearty manufacturers remaining over the years where others have failed to survive. One of the area's oldest employers, Woolrich, Inc., opened its doors in 1830 and remains a top international maker and retailer of apparel.

But other companies have not survived hardships that are not unlike those seen in other towns along the Susquehanna River. Fires, economic depression, influenza, and floods have all played roles in periodically destroying industry. Many smaller businesses also have disappeared over the years because of these same factors. Major floods have indiscriminately ruined businesses and homes in 1889, 1918, 1936, and 1972. Construction of a levee system in Lock Haven followed in the 1990s to get a thorough testing in September 2004 with Hurricane Ivan. Although Lock Haven would be mostly unscathed, nearby Mill Hall saw a lot of damage to homes and businesses alike. On the eastern side of the county, many homes in Avis and the surrounding area also were hit with flooding, and it seems that much of the county is still susceptible to future flood damage.

But despite the various hardships, the county continues to thrive and survive and maintain its own identity. Perhaps one of the most enduring traits displayed by its residents is that of service, which may largely be a part of the survival of the county. There always has been a strong group of volunteers to run the local fire services and help others in times of need, braving both flood and fire to save lives. From the Revolutionary War, all the way to the current war in Iraq, those who hail from the county have filled the ranks of the nation's various branches of armed services. There always has been a strong tradition of philanthropy and fund-raising for causes that need support. And there are those who step forward to run for elected office who are responsible for much of the civil structure that exists today in Clinton County.

The endurance of the people of the county can be seen in their continuing devotion to education. From the days of the one-room schoolhouses, to the controversial times of consolidation, education still remains an important topic of debate and concern. And Lock Haven University remains a major area employer, still turning out qualified teachers as it did when it was founded as the Central State Normal School in 1870. This liberal arts university, 1 of the 14 Pennsylvania State System of Higher Education schools, continues to grow both in terms of programming and facilities.

The endurance of people who call Clinton County home can be seen in the various social activities that have occurred over the years. The occasional floods that have hit the region have not stopped parades, holiday events, social club activities, and leisurely gatherings from going on. People continue to enjoy themselves and find companionship with others who participate in the same activities and have the same interests.

Clinton County continues to draw the interest of those from outside of its borders. It remains a place of great natural beauty, and sportsmen flock to the area to fish and hunt game. It remains a place of continuing economic development and is home to new and emerging industry. And it is a place of pride for those who have always called it home, whose families and ancestors are seen in the photographs of this book, Images of America: *Clinton County*.

One

FOUNDERS AND FOUNDATIONS

The first chapters of John Blair Linn's respected 1883 work titled *History of Centre and Clinton Counties* read like James Fennimore Cooper as Linn documented the region as it was in the 18th century.

Native American inhabitants in the early and mid-1700s included the Monsey group of Lenni Lenape, known to settlers as Delaware, and the Shawnee, denoted as "Shawanese," who were under the jurisdiction of the Iroquois while in the area. During this early point in history, the paths and trails through Clinton and Centre Counties were fraught with peril. The Lenni Lenape often sided with the French in Linn's accounts, with the Shawnee remaining an ally to English settlers despite land disputes and encroaching settlement. It was not an easy time as both white and Native American settlements alike were burned to the ground in the region.

Encroachment would reach a breaking point in 1778, as settlers would end up leaving the region in the "Big Runaway" due to native hostility. They would not return until the conclusion of the Revolutionary War when the Second Stanwix Treaty would open the gates for settlement.

Over the years, the distinct towns and municipalities would emerge, often due to industry, enterprise, and development. Dunnstown, once known as Dunnsburgh, was home to the county's first post office in 1805. Clinton County would officially be formed in 1839, with Bald Eagle, Beech Creek, Greene, Lamar, Logan, and Porter Townships coming from Centre County, and the remainder of the county's 12 townships coming from Lycoming County. Lock Haven officially became the county seat in 1844.

The municipalities have changed over the years, as evidenced in historical photographs of the region. Although many landmarks have disappeared or look different as they have aged, they are still preserved through photography.

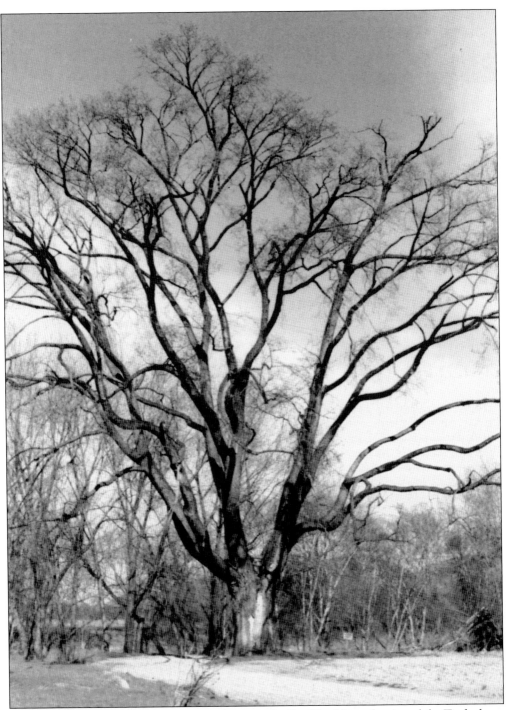

McElhattan and the Pine Creek area were home to the Fair Play Men, who signed the Tiadaghton Declaration of Independence on July 4, 1776, under this tree. The Fair Play system had three appointed commissioners who settled disputes, mostly over land, and governed an area that extended from Pine Creek to Lycoming Creek in Lycoming County. The Fair Play system was in place from 1773 to 1778. (Courtesy of the Annie Halenbake Ross Library.)

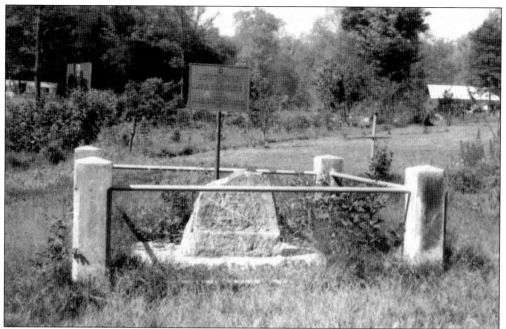

This stone marker shows the location of the site of Fort Horn near McElhattan. Samuel Horn, a German pioneer, constructed a log cabin that was fortified around the time of the start of the Revolutionary War to protect against Native American attack. The stockade of the fort consisted of a fence of heavy logs some 12 feet high. (Courtesy of the Clinton County Historical Society.)

A monument marking the location of Fort Reed was placed by the Grafius House, pictured here at 217 East Water Street in Lock Haven in 1899. Fort Reed is Lock Haven's pioneer fort named after settler William Reed. The actual location of the fort is still under debate as another possible site is the Heisey Museum, 362 East Main Street. (Courtesy of the Clinton County Historical Society.)

Jeremiah Church is credited with the founding of Lock Haven. He obtained title to 200 acres of farmland between the Susquehanna River and Bald Eagle Creek in 1834. The land was divided into plots that were sold off and was formally incorporated as the borough of Lock Haven in 1840 with around 700 residents. (Courtesy of the Clinton County Historical Society.)

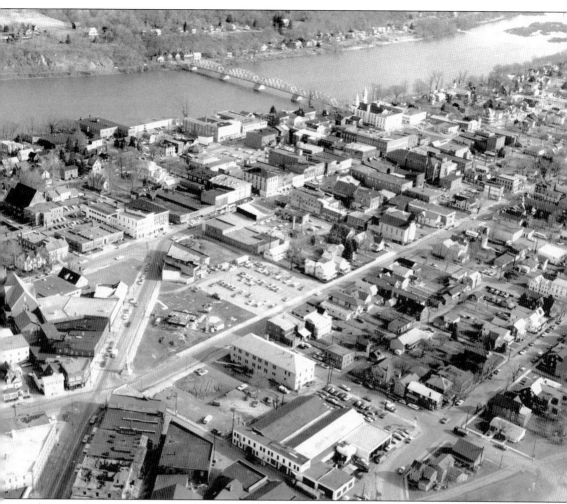

The city of Lock Haven is seen in this aerial photograph taken in 1974. After its founding, Lock Haven would become the center of business and industry in Clinton County and was named the county seat in 1844. By 1870, Lock Haven would be upgraded from a borough to a second-class city. Today's estimated population is around 9,000 residents. (Courtesy of the Annie Halenbake Ross Library.)

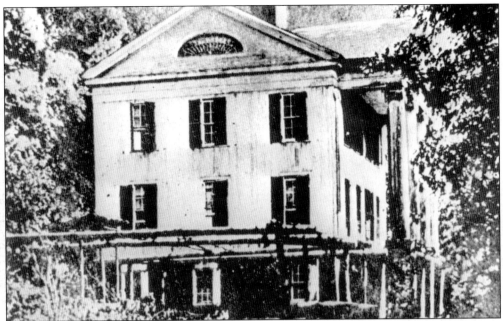

Farrandsville, founded by William P. Farrand and established as a village in 1831, was home to the queen's mansion, financed by Spanish queen Isabella II. She ruled until 1868, when she was forced to flee to France. Before her exile, she protected her fortune by placing it in the hands of Philadelphia bankers the Fallons, who built the mansion as a royal refuge. (Courtesy of the Clinton County Historical Society.)

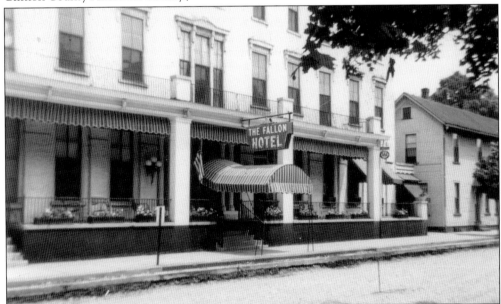

The Fallon House, located on East Water Street in Lock Haven, was built in 1855 by Queen Isabella II's agents, the Fallons. Other investments made on behalf of the queen include mining and iron operations in Farrandsville and Washington Iron Works in Lamar. The queen's enterprises did not succeed financially, but the Fallon House remains a familiar Lock Haven landmark. (Courtesy of the Annie Halenbake Ross Library.)

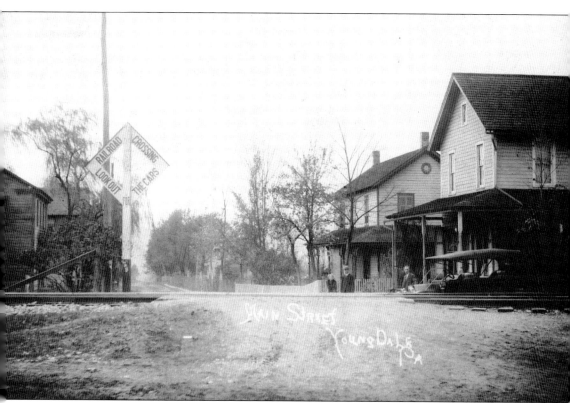

Small communities developed in Clinton County over time based on what they had to offer, such as a railroad or post office. The community of Youngdale, seen in this undated photograph, was the site of a post office built in July 1892 and was a railroad stop for the Beech Creek Railroad. This photograph is of Youngdale Main Street. (Courtesy of the Annie Halenbake Ross Library.)

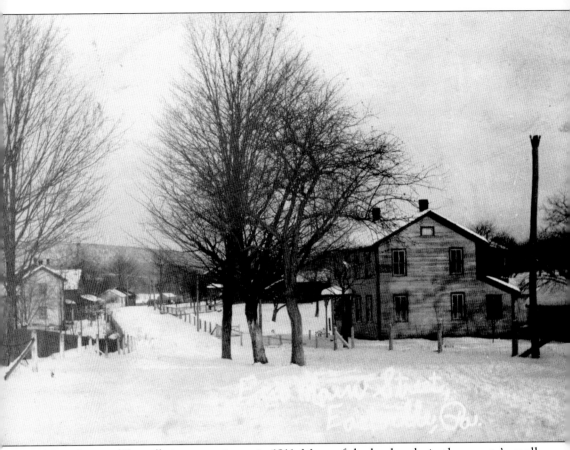

Main Street of Eastville is seen as it was in 1911. Many of the landmarks in the county's small towns and villages are known by their former owners. The house on the right was occupied by Edgar Schwenk. The buildings on the left were the house and store of C. C. Brungard. The third set of buildings on the left were the home and shop of David Guiseweit. (Courtesy of the Annie Halenbake Ross Library.)

Two

Getting There by Wagon, Boat, Train, or Automobile

Early transportation in the region occurred along existing Native American paths. When lumbering was established, the industry first used the Susquehanna River to raft logs to nearby Williamsport before a boom system was put in place where logs could float freely. But lumbering also is responsible for the construction of railroads, bridges, and roadways in Clinton County.

During the time of the Great Depression, the Civilian Conservation Corps (CCC) was created for the purpose of finding useful work for unemployed young men. It was through the CCC camps and the federal Works Progress Administration (WPA) that over 257 miles of roads and 29 miles of streets would be improved in the county.

The progression of transportation in the county is as it was with other towns along the Susquehanna, going from a reliance on horse and carriage and raft and waterway to the use of locomotives, and eventually automobiles. Built in 1894, a trolley system was a means of travel in the city of Lock Haven until 1930, when it was outmoded by bus transportation, which no longer exists today. Over the years, the bridges changed from ramshackle structures designed to barely let someone pass, to covered wooden structures that were eventually replaced with steel and then with concrete.

Today Interstate 80, a highway that goes from New York City to San Francisco, runs through Clinton County. Residents need only to enter the eastbound or westbound on-ramp to head to other parts of the country.

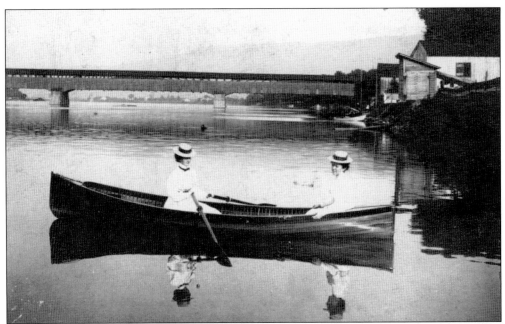

The Jay Street covered bridge over the West Branch of the Susquehanna River at Lock Haven was built in 1852 and burned in 1919. These photographs show the bridge as it looked from the Lock Haven (above) and Lockport (below) sides on August 20, 1898. Pennsylvania is the original state of the covered bridge, with the first one being built over the Schuylkill River in Philadelphia in 1800 by Timothy Palmer. Bridges were covered to protect the side supporting beams rather than just the floorboards. At one point, Pennsylvania had over 1,500 covered bridges, and around 200 still remain throughout the commonwealth in 40 counties. (Courtesy of the Clinton County Historical Society.)

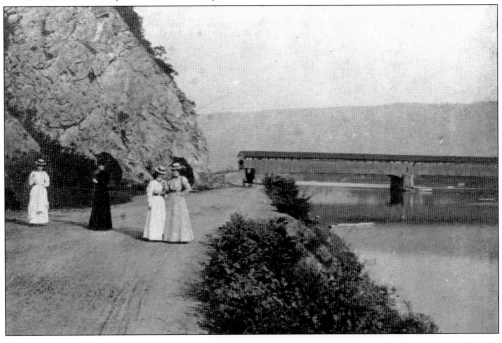

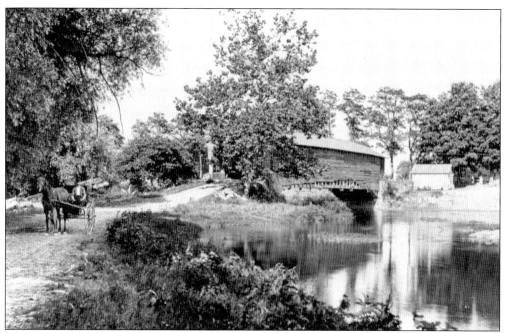

Seen here in this photograph taken around 1895, the first covered bridge over Bald Eagle Creek was built in 1820. Bald Eagle Creek is a tributary of the West Branch of the Susquehanna River with its mouth some two miles east of Lock Haven. Iron products and lumber were once floated down Bald Eagle Creek from Centre County. (Courtesy of the Annie Halenbake Ross Library.)

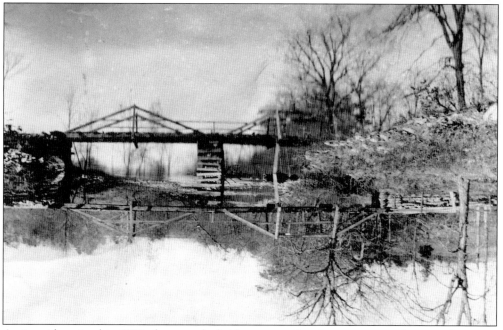

As is evident in this 1936 photograph, bridges were often just a means of getting from one side of a body of water to another. The precarious center support of this makeshift bridge in Mackeyville is made of stacked, shaved logs while the floor of the bridge consists of uneven lengths of board. (Courtesy of the Annie Halenbake Ross Library.)

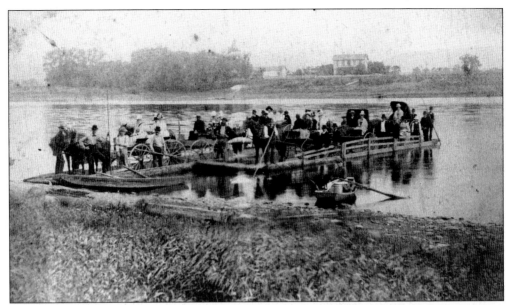

At least five carriages can be seen in this undated photograph of the Quiggle Ferry at Pine Creek. Travel by ferry could be hazardous at times. The December 7, 1889, *Evening Express* describes a wedding party of 10 wagons that was unable cross in the Pine Creek ferry but made it to the ceremony in time thanks to an old scow. The wagons were left behind, the article stated. (Courtesy of the Clinton County Historical Society.)

After the Jay Street covered bridge over the Susquehanna River burned in 1919, two years went by until another bridge was built. In the meantime, the Clinton County commissioners operated a free ferry. The scene is looking at the approaching ferry from the ferry landing on the Lock Haven side of the river on October 1, 1921. (Courtesy of the Annie Halenbake Ross Library.)

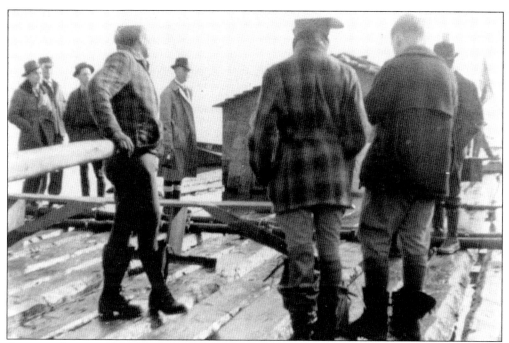

A river raft approaches the Grant Street Dam in March 1938. It may have been the last river raft to go through the West Branch of the Susquehanna River. Dams constructed along the river no longer allow for continuous travel by boat or other watercraft. In the county's early history, the early colonists received supplies that were brought in by 20-to-25-ton boats that were driven by human power through the use of long poles. Rafts were later used to transport lumber to nearby Williamsport until a boom system was installed in 1851 allowing for the lumber to float freely. Rafts were also used by much of the county's industry, although rail, and eventually the automobile, outmoded the reliance on water transportation. (Courtesy of the Annie Halenbake Ross Library.)

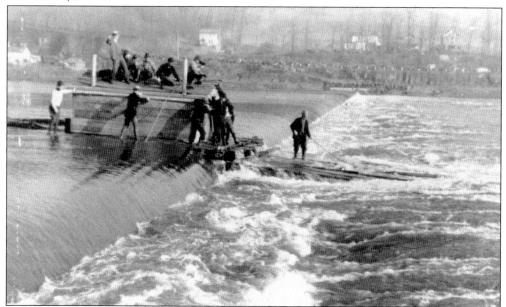

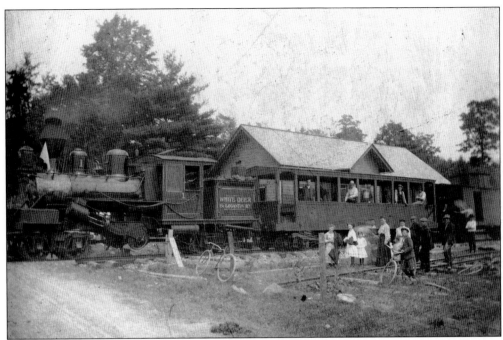

The White Deer and Loganton Railroad served to haul lumber harvested in the Sugar Valley area, with an engine, its passengers, and a number of onlookers seen here in Loganton in 1890. It was one of the county's 12 logging railroads that were primarily used for lumber transportation from 1875 until 1910. (Courtesy of the Annie Halenbake Ross Library.)

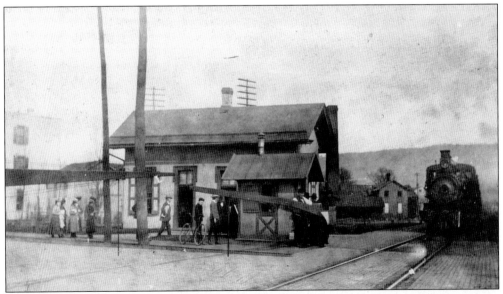

Passengers stand in line to purchase tickets and board a train that is waiting for departure at this railroad station on Bellefonte Avenue in Lock Haven around 1901. The Bald Eagle Valley Railroad, built in 1865, went directly through Lock Haven. It was purchased by the Pennsylvania Railroad in 1908. (Courtesy of the Annie Halenbake Ross Library.)

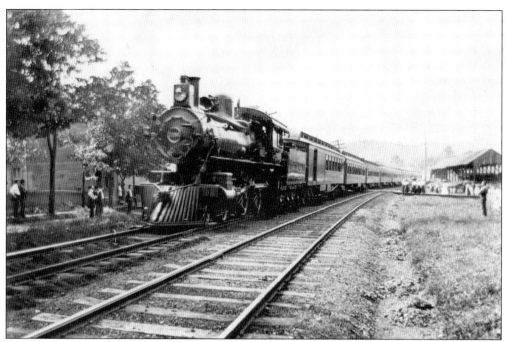

After the assassination of Pres. William McKinley, a funeral train carrying his body passed through Lock Haven on September 16, 1901. The photograph above shows the train crossing Vesper Street. The photograph below, taken by J. W. C. Floyd, who sold copies of the image, shows the train at the city's lower depot. McKinley's body was reported to be in the rear car, and his wife was in the car in front of it. Pres. Theodore Roosevelt and his cabinet were in the third car from the rear. Well before the train arrived, crowds had gathered at the passenger stations and tracks. Local schools were not in session as children were required to turn out for the event with uncovered heads. People placed coins on the track to be flattened by the train and kept as souvenirs. (Courtesy of the Annie Halenbake Ross Library.)

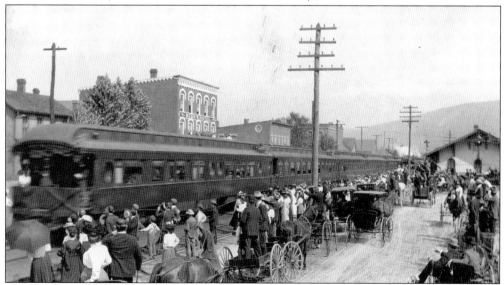

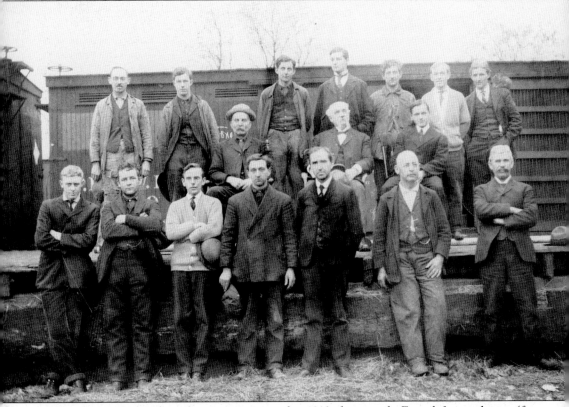

Pennsylvania Railroad employees are seen in this 1910 photograph. From left to right are (first row) Bill Mader, Ed Blake, Elmer Snyder, Irvin Blesh, Ed Gross, Jacob Waterman, and Charles Kane; (second row) Patrick King, Francis K. Smith, and Bob Huling; (third row) Bill Young, Ira Truckenmiller, Pete Smith, Al Williamson, Harry Weaver, Dave Lawrence, and Fred Ubil. (Courtesy of the Annie Halenbake Ross Library.)

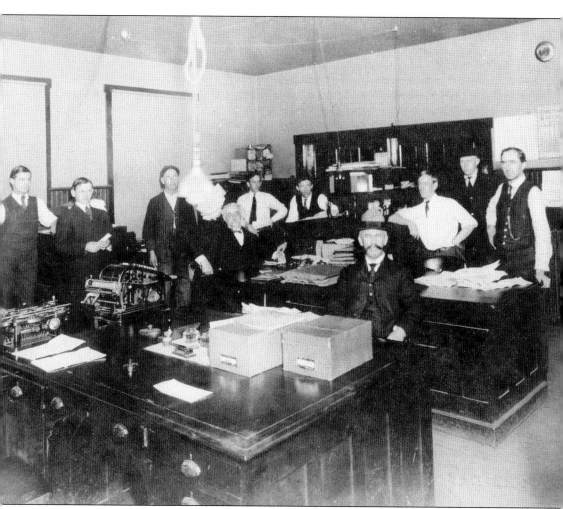

A group of sharply dressed workers takes a break for a portrait at the Pennsylvania Railroad freight office in Lock Haven. The group portrait includes Al Williamson, Bob Huling, Jacob Waterman, Elmer Snyder, S. Dare Lawrence, Ed Gross, Francis K. Smith, and Charles F. Kane. The photograph was taken on December 16, 1908. (Courtesy of the Annie Halenbake Ross Library.)

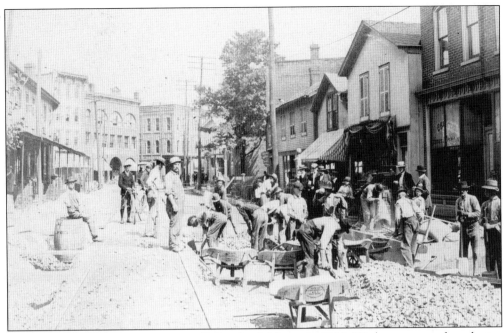

An electric streetcar system was installed in Lock Haven in 1894. Workers are seen here laying tracks along Bellefonte Avenue in the city. In 1895, the trolley line was extended to Mill Hall. A line also was constructed in South Avis that extended to Jersey Shore. The trolleys were operated by the Susquehanna Transit Company. (Courtesy of the Annie Halenbake Ross Library.)

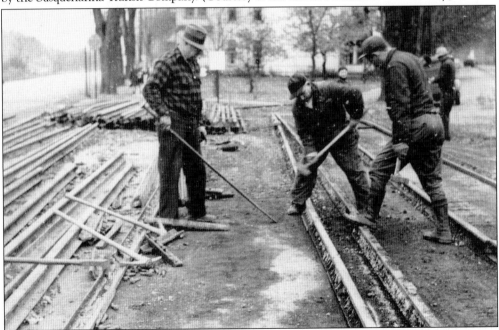

A crew of workmen breaks apart trolley tracks that were removed from West Main Street in Lock Haven. As the automobile became a preferred means of travel, the Susquehanna Transit Company switched from electric trolleys in 1930 to busses. The busses originally followed the same routes that the trolleys did. (Courtesy of the Annie Halenbake Ross Library.)

The house in the above photograph in Carroll was referred to by locals as the "State House." It was used for quarters for CCC workers and eventually became a local residence. The lower photograph is of a group of CCC workers in Farrandsville. The federal government established the CCC camps in Green Lick, Hyner, Keating, Loganton, Lucullus, Tamarack, Pine, State Camp, and Farrandsville in the early 1930s. The camps were bolstered by the WPA that came into existence in 1935. Under the WPA, miles of roadway, drainage ditches, and other county infrastructure were completed and public buildings were renovated and repaired. (Above, courtesy of the Annie Halenbake Ross Library; below, courtesy of Vickie Hibbler.)

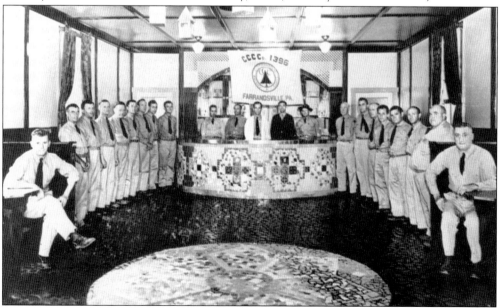

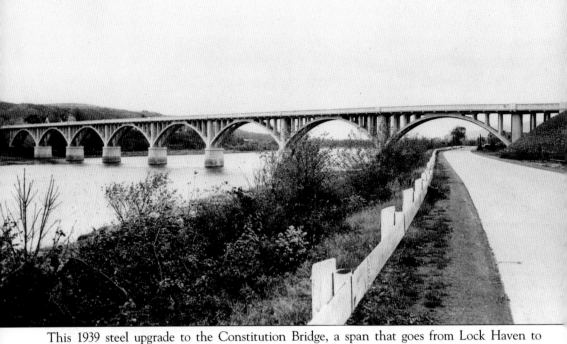

This 1939 steel upgrade to the Constitution Bridge, a span that goes from Lock Haven to Dunnstown over the West Branch of the Susquehanna River, illustrates how transportation is ever changing as new materials and technology make for better travel. The engineer of the 1939 upgrade was Thurston H. Smith. (Courtesy of the Clinton County Historical Society.)

Three

INDUSTRY AND BUSINESS, BIG AND SMALL

After the skirmishes of early settlement, farming was the main pursuit of those who called Clinton County home. Tobacco growing was introduced into the area in the late 1830s and continued to be an agricultural staple over the years, with some tobacco cultivation existing into the 1980s.

But it was the lumber industry that allowed settlers to get a true foothold on development and create supporting businesses. With an abundant supply of lumber in the region and the presence of the Susquehanna River, combined with developments in steam-driven mill technology, many individuals profited from lumber between 1850 and 1889. The development of a boom system during this period further enhanced lumber production, and the era of rafting lumber down the river ended.

A railroad system was developed and caused the county's population to swell, with nearly 18,000 new residents settling in Clinton County between 1850 and 1899. County seat Lock Haven saw nearly 1,500 new homes during that time frame.

The decline of lumbering began after the great flood of 1889, and it was replaced with new industry that was often controlled by corporations not based in the county or state. Industrial success truly depended upon the year, with floods, fires, influenza, and the Great Depression having a negative impact.

Regardless of these adversities, industry diversified, with Clinton County seeing a number of brickmakers, coal mining operations, tanneries, furniture manufacturers, and chemical companies. Lock Haven, Mill Hall, Beech Creek, South Avis, and Farrandsville were thriving centers of manufacturing. Even though lumber had declined, paper manufacturing and printing companies were the county's largest employers by 1930.

Aviation would eventually unseat paper and printing companies, and Piper Aviation would become the largest county employer in the 1940s and 1950s, spurred on by the industrial growth that occurred during World War II with over 5,000 Piper Cubs produced for the federal government.

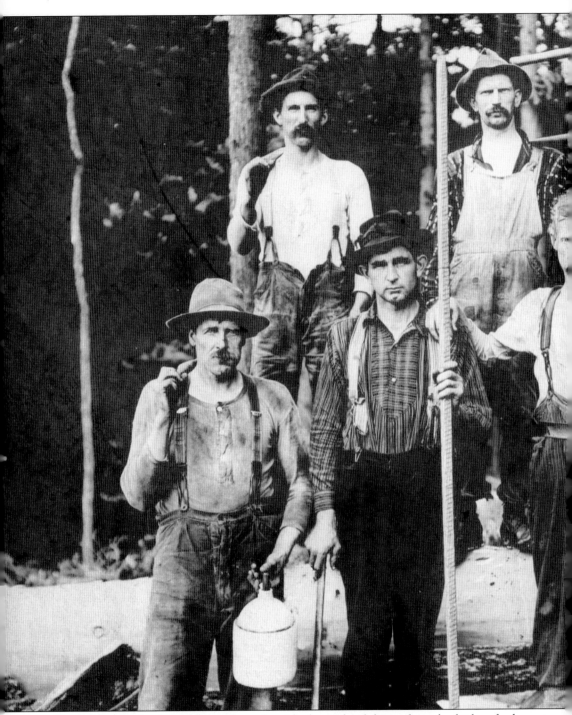

This eight-man lumber crew stands ready with the tools of the trade and a little refreshment, perhaps not looking any different than the myriad of crews that would work in the forests for well over 100 years. The first sign of lumbering in Clinton County was the 1771 naming of Bald Eagle Creek as a public highway for arks that went to the Susquehanna River delivering yellow and white pine and hemlock. The first mills, called "tub mills," were small operations that ran

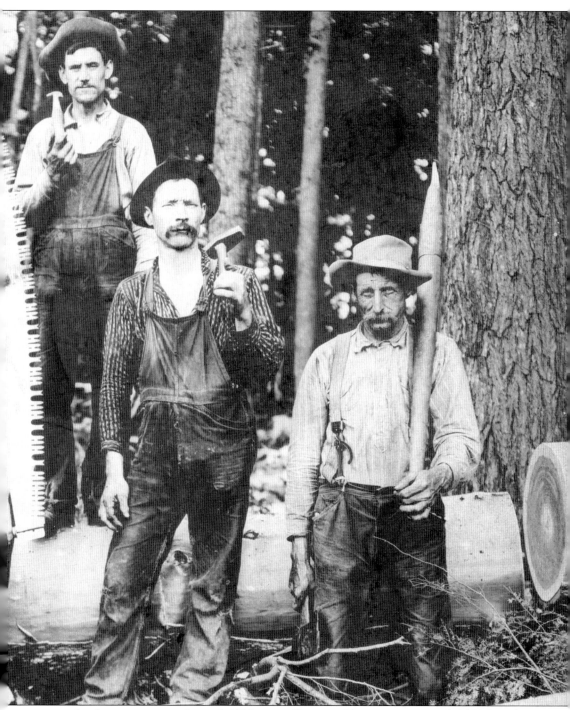

opposite the farming season. Around 1800, sawmills were able to move around 1,000 board feet a day, and white pine was a hot commodity. Before 1850, lumber rafts were able to move 50,000 to 70,000 board feet of lumber at a time. Booms were built in the 1850s that allowed for free-floating log-driving operations. (Courtesy of the Clinton County Historical Society.)

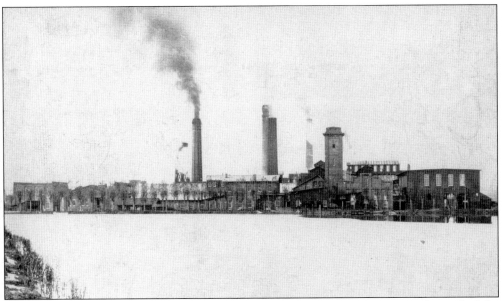

Lumbering brought in several related industries, many of which survived past the end of the lumbering era, including paper production. The New York and Pennsylvania Company, seen in this early photograph and a later aerial image, manufactured stock for the likes of the *Saturday Evening Post* and *Ladies' Home Journal*. The company was the county's largest employer in 1930. Hammermill bought the plant in 1965, and at the time, it was capable of producing 150,000 tons of paper a day. Hammermill was purchased by International Paper in 1987, and the Lock Haven plant continued operations until operations were permanently closed in March 2001, when the mill was capable of producing 230,000 tons of paper a day. Since then, First Quality Products, Inc., a manufacturer of disposable sanitary paper products, has purchased the plant and it is currently in full operation. (Courtesy of the Annie Halenbake Ross Library.)

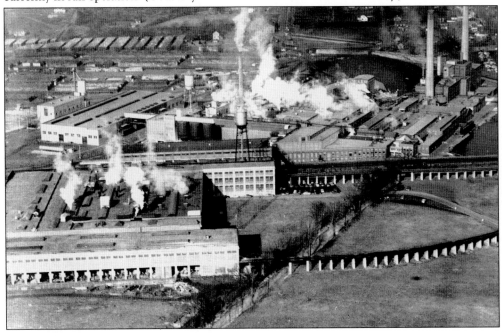

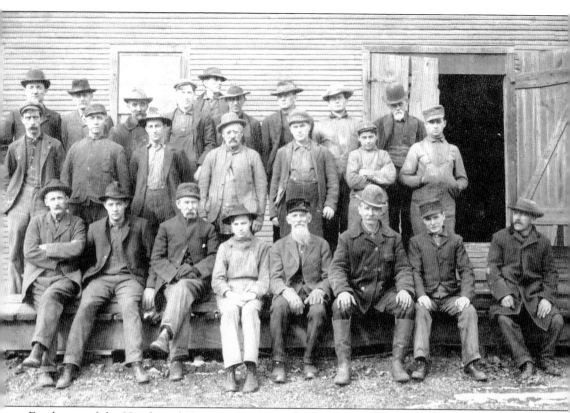

Employees of the Hipple and Kintzing planing mill, which once occupied a site on Bellefonte Avenue in the Commerce Street area on the north side of the street, pose for a photograph, the year is not known. The man in the derby, at the left in the third row, is Ernest J. Herman, a foreman who specialized in reading the blueprints and was known as "the colonel." (Courtesy of the Annie Halenbake Ross Library.)

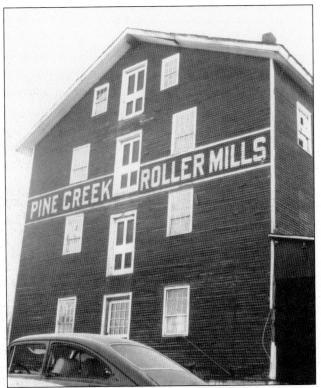

Agricultural mills are some of the oldest business enterprises in Clinton County. Pine Creek Roller Mills, Pine Creek Township, is no longer in existence, and its exact location is unknown. A former co-owner was Margaret R. Gettys, who lived in Jersey Shore and died at the age of 81 on February 3, 1994. (Courtesy of the Annie Halenbake Ross Library.)

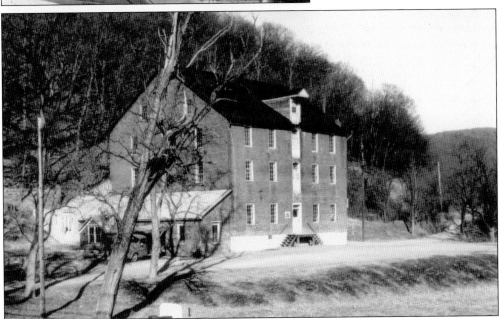

The Chatham Run Mill is still standing outside Woolrich in Pine Creek Township. This three-story Flemish and common bond brick structure is located on the north side of State Route 150. The gristmill was constructed around 1820 by Andrew Ferguson. Water for operating its machinery was obtained from Chatham Run, hence the mill's name. (Courtesy of the Annie Halenbake Ross Library.)

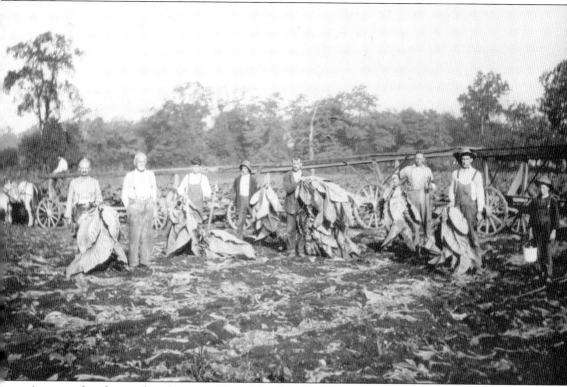

A group of workers picks tobacco on Great Island. Tobacco was a major crop in Clinton County, having been introduced in 1838 and reaching the status of a major industry by the 1890s. There were several cigar-making operations in the county, with early cigar manufacturers showing up in the 1860s. The tobacco fields were reported to be the highest north in the United States. The initial average yield per acre for tobacco was 12,000 pounds, which by the 1940s was up to 15,000 to 16,000 pounds. Tobacco farming remained at seven to eight percent of the county's agricultural production from 1880 into the 1940s. (Courtesy of the Annie Halenbake Ross Library.)

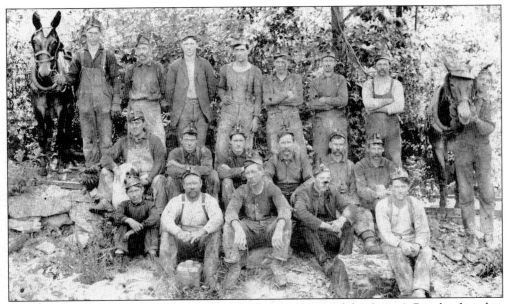

A group of clay miners poses for a portrait in 1900 at the site of the Queen's Run brickyard in Woodward Township. Clay miners used mules to haul the clay up from the interior of the mine. Brickmaking in the county was popular for over 100 years, beginning in 1836 and dying in 1958, although one prominent brickmaker, Mill Hall Clay Products, remains in operation. (Courtesy of the Annie Halenbake Ross Library.)

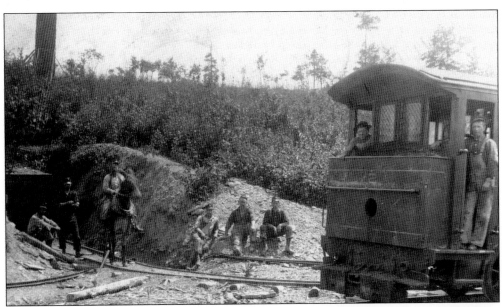

Miners take a break outside a coal mine near Beech Creek in 1908. Beech Creek was home to both coal and clay miners. Coal mining at nearby Tangus in the 1920s took place from Monday through Saturday, with workers returning to their homes and families in Beech Creek for just one day a week. (Courtesy of the Annie Halenbake Ross Library.)

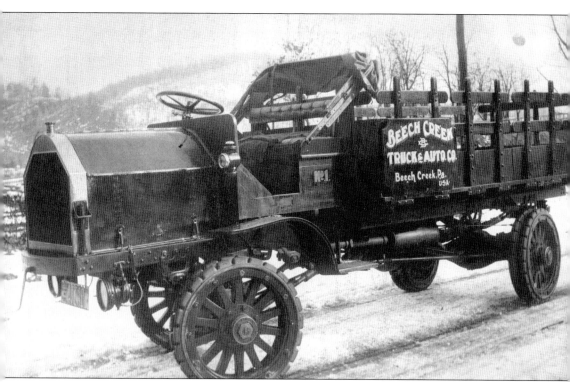

One of the earliest reported four-wheel-drive trucks ever made was in Beech Creek in 1915 by the Beech Creek Truck and Auto Company. Clinton County judge Henry Hipple filled out the charter paperwork for the company, according to a *Lock Haven Express* article. The truck was hailed as being able to move in snow or mud up to its axles, and one-and-a-half- and three-ton capacity models were advertised for sale. The cost for the standard chassis was $3,850. But people were reluctant to give up their horses and wagons at the time of the truck's production. The company was unsuccessful due to a lack of capital and was over $10,000 in debt when it was auctioned off in 1920. (Courtesy of the Clinton County Historical Society.)

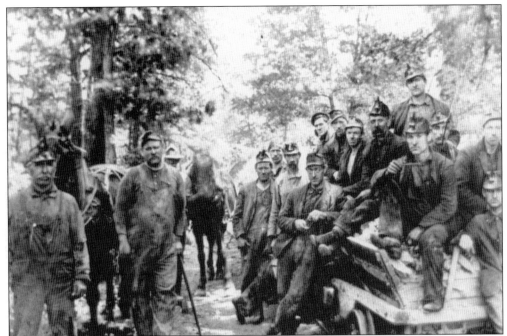

Miners work to bring up clay in Farrandsville, which also was the home of coal mining. Bringing up the clay was only the first step in the brick-making process, and before 1879, it had to all be done painstakingly by hand shovel as the steam shovel was not yet invented. Clay brought up by the miners was either ground into a powder and screened or soaked for molding. Brick molds were used to form the bricks by another team, and then the bricks had to be air dried before they were sent to a kiln that was fueled by wood or coal, baking the bricks in temperatures that reached up to 1,800 degrees Fahrenheit. (Courtesy of the Clinton County Historical Society.)

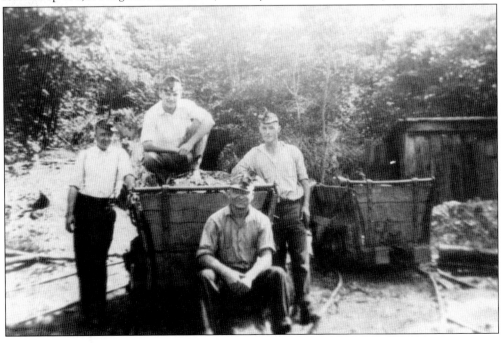

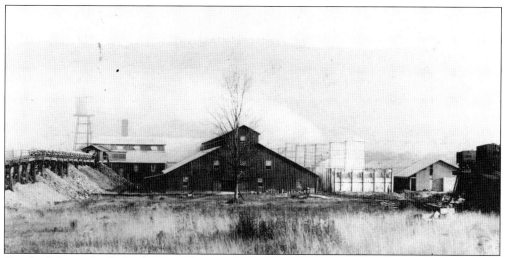

On the left, tracks for bringing in clay can be seen in this undated photograph labeled "Brick Works, Beech Creek PA." On the right can be seen the brick drying kilns. Beech Creek was the home of General Refractories Company, which in 1930 also operated a plant in Mill Hall. The company closed its doors in Beech Creek in the early 1950s. (Courtesy of the Annie Halenbake Ross Library.)

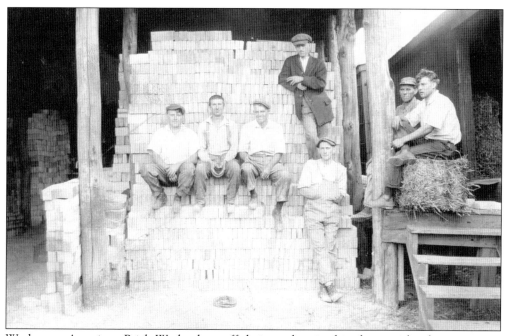

Workers at American Brick Works show off their product in this photograph taken sometime before World War I. The men are identified as, from left to right, Cyrus Rote, Jim Freeze, Blair Tate, Lollypop Brown (front), Charles MacGregor (rear), Bounce Robb, and Chan Kryder. The company, located between Flemington and Mill Hall, became the site of Bald Eagle Chemical. (Courtesy of the Annie Halenbake Ross Library.)

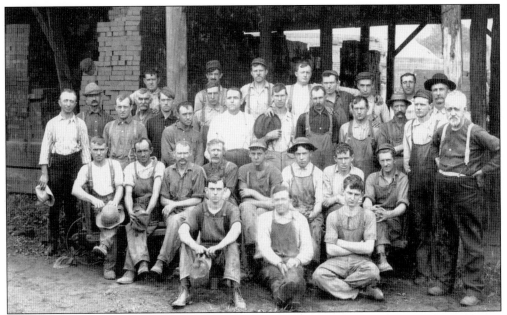

The Mill Hall Brick Works crew poses for a photograph in August 1909. In 1893, Mill Hall Brick Works received a commendation at the World's Columbian Exposition in Chicago for the specialty brick and shale pavers it manufactured. Brickmakers in Clinton County that had specialty products are reputed to have achieved a greater prosperity. (Courtesy of the Annie Halenbake Ross Library.)

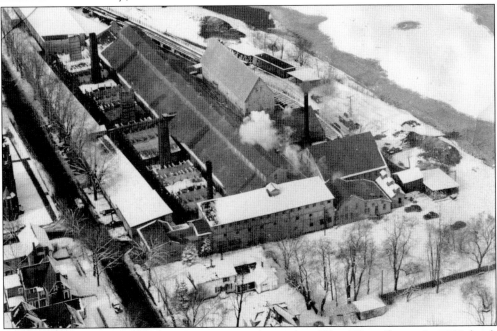

North American Refractories, Lock Haven, was located on West Water Street. In 1888, brick production in the Lock Haven area was estimated at around 20,000 bricks per week. In the 20th century, that number climbed to 201,000 per week. (Courtesy of the Annie Halenbake Ross Library.)

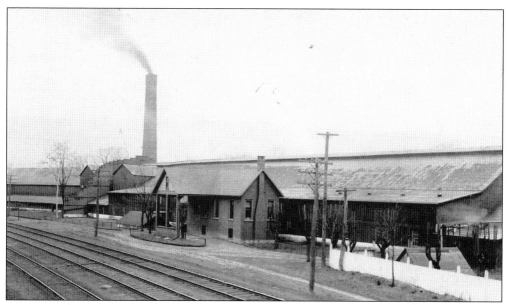

Tanneries also were among some of the earliest successful ventures in Clinton County, with an early tannery existing in Dunnsburg, which became Dunnstown. The West Branch Tannery, seen here, was owned by the Kistler brothers and was established in 1870. Lock Haven also was home to Myers, Herring and Company, a tannery established in 1858. (Courtesy of the Annie Halenbake Ross Library.)

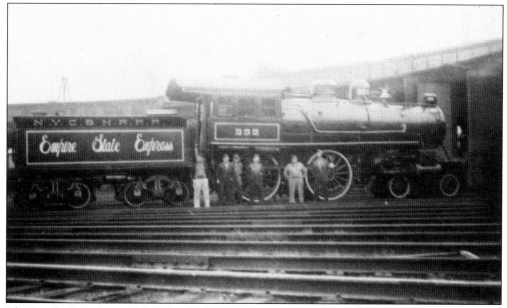

The South Avis shops of the New York Central System produced the 999 *Empire State Express* locomotive that was the subject of a 1901 U.S. Postal Service stamp. The locomotive was on display at the World's Columbian Exposition of 1893 and was known as "the fastest passenger train in the world." In 1893, it set a speed record at 112.5 miles an hour. (Courtesy of the Annie Halenbake Ross Library.)

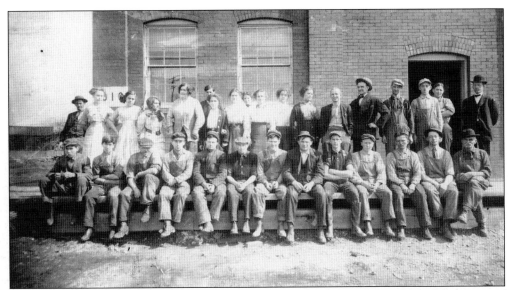

Clinton County was the home to the Mill Hall Condensory located at the corner of Pennsylvania Avenue and Market Street, Mill Hall. Identified workers in the photograph are Frankie Prickelmyer Stewart, Mary Prickelmyer Klinger, Idabelle Miller Caites, Irvin Harry, and Ed Mincer. Others are unidentified. The year of the photograph is unknown. (Courtesy of the Annie Halenbake Ross Library.)

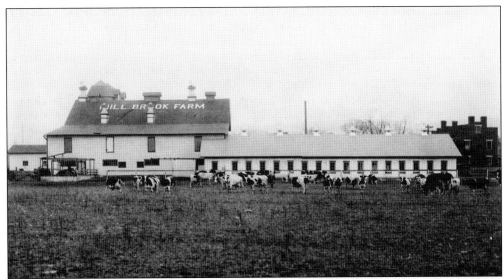

This barn on Country Club Lane, Mill Hall, is the site of the Millbrook Playhouse, which started producing plays in 1962 and is still active to this day. The barn, built around 1920, was formerly owned by Sedgewick Kistler, whose Holstein cattle imported from Holland were registered under the name Millbruek, a Dutch derivative of "mill brook," as there once was a gristmill located north of the barn. (Courtesy of the Annie Halenbake Ross Library.)

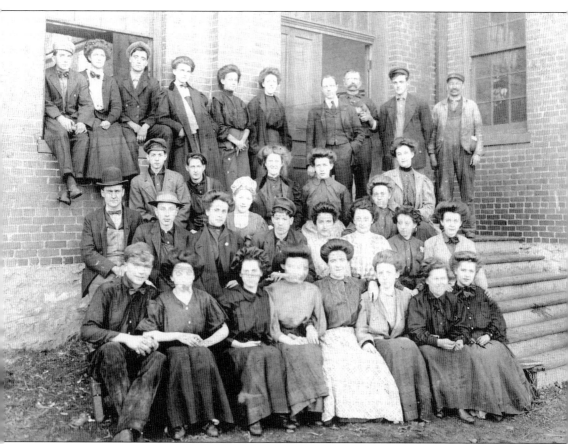

This photograph, taken around the founding of the company in 1904, shows employees of the Pennsylvania Woven Wire Mill, the predecessor of Pennwoven, Inc., which no longer exists. The company was formed by local entrepreneurs to weave wire cloth for screens. Employees that have been identified, from left to right, are (first row) George Kinley, Esther Derr Bridgens, unidentified, Edna Poorman Nonemaker, Ruth Bilbay Bower, May Kissell, Laura Nestlerode Brown, and Amy Nestlerode Baker; (second row) William Eberhart, James Long, Ruth Hanna, George Brown, unidentified, Kathleen Deise, Ruth Smith Farwell, and Eva Keister Brickley; (third row) Fount Brown, Ray Carter, Wilda Johnson Fredericks, Edna Remick, Ruth Poorman Lovett, Clara Poorman Batdorf, and Dessie Remick; (fourth row) Albert Meckley, Babe Withee, Joseph Nestlerode, unidentified, Ida Brendal, Helen Calderwood Eyer, George Kreamer, unidentified, Harry Marks, and Charles Gramley. (Courtesy of the Annie Halenbake Ross Library.)

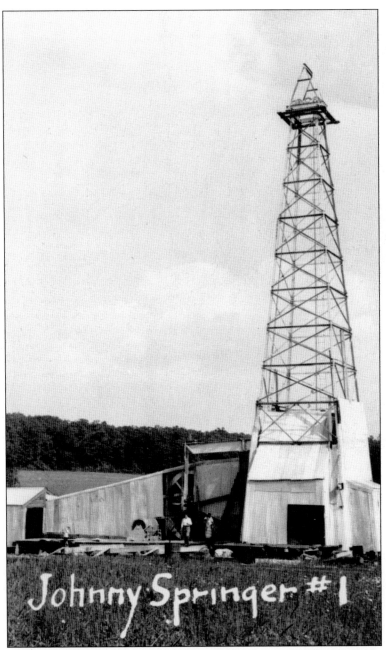

Drilling for natural gas ended at the Johnny Springer Well near Caldwell in Gallagher Township in May 1952. The well did not produce after drilling went to a depth of 8,257 feet when the bit struck sand. Operations at the well lasted 11 months and were fraught with difficulty as tools were lost down the well's shaft and sealed off by cement. There were natural gas blowouts at 8,200 and 8,240 feet. A geology report noted that the gas sought by the Winner-Murphy drilling outfit could have escaped through a crevice. A second well in the Caldwell area, owned by Manufacturers Light and Heat Company, was successful, initially producing 33,000 cubic feet of natural gas a day at the time that the Johnny Springer well project was abandoned. (Courtesy of the Annie Halenbake Ross Library.)

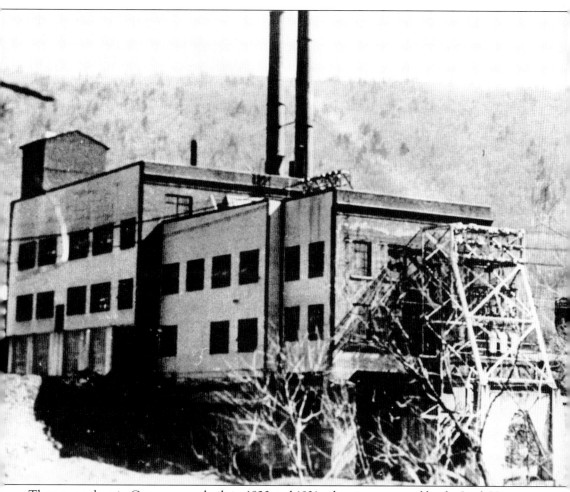

The power plant in Castanea was built in 1920 and 1921, when it was owned by the Lock Haven Electric Light, Heat and Power Company. It was a larger plant than others in the area and was capable of generating more power. Pennsylvania Power and Light Company (PPL) took over the Lock Haven Electric Light, Heat and Power Company in 1923. Prior to the PPL acquisition, the Lock Haven Electric Light, Heat and Power Company merged with companies in Castanea, Bald Eagle, Dunnstable, and Woodward Townships and with Mill Hall and Flemington boroughs. Around the same time, telephone service was becoming available to much of the county and was reported to have arrived in the Beech Creek area in 1909. Electricity came later to Beech Creek in 1920, and public water followed in the mid-1930s. In Avis borough, telephone service arrived in 1910, electrical lines were established between 1914 and 1916, and a public sewer was installed in 1928. (Courtesy of the Annie Halenbake Ross Library.)

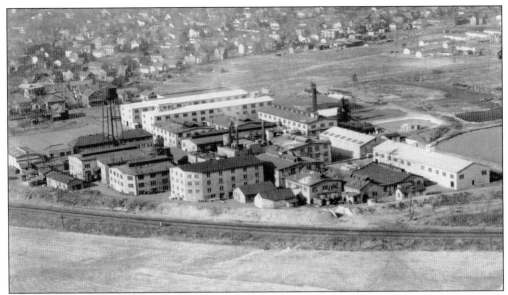

American Color and Chemical Company, formerly located on Mount Vernon Street, Lock Haven, closed in 1982. The company manufactured clay pipes and chemicals such as phenols and dyes. Dye and battery manufacturers were among some of the county's chemical companies, and today the county is home to glue and adhesive and personal care chemical companies. (Courtesy of the Annie Halenbake Ross Library.)

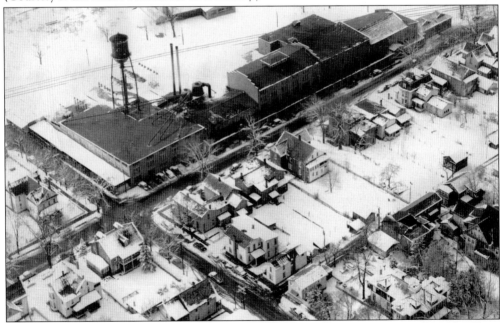

The R. K. Griffin Company chair factory, once located on Church and Fifth Streets in Lock Haven, burned in 1956 but managed to rebuild. In 1968, it was purchased by Lock Haven Norquist Products, Inc., which closed its doors in 1970. Furniture manufacturing was a side industry that was started by the lumber boom and picked up steam in the early 20th century. Early chair makers Ringler and Xavier are recorded in advertisements in 1854 as saying they made "all sorts of chairs." (Courtesy of the Annie Halenbake Ross Library.)

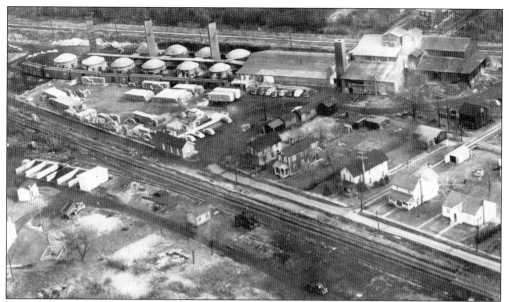

In operation for over 100 years, Mill Hall Clay Products is still going strong, located on Market Street in Mill Hall. In this undated aerial photograph, the kilns for baking the bricks can be seen in the upper left-hand area of the photograph. Today the company owns hundreds of acres of clay lands and uses modern equipment. The company sells flue liners, chimney tops, drain tiles, and brick. The company has long outlasted the other brickmakers in Mill Hall and Lock Haven. (Courtesy of the Annie Halenbake Ross Library.)

Sylvania Electric Products, Inc., on Pennsylvania Avenue in Mill Hall is seen from the air. During World War II, this plant manufactured vacuum tubes that were purchased by the federal government. Sylvania Electric Products was a U.S. manufacturer of diverse electrical equipment, including various radio transceivers and mainframe computers. The remaining Sylvania operations are a U.S. subsidiary of German-owned Osram; they once were owned by General Telephone and Electronics before being acquired by Osram. (Courtesy of the Annie Halenbake Ross Library.)

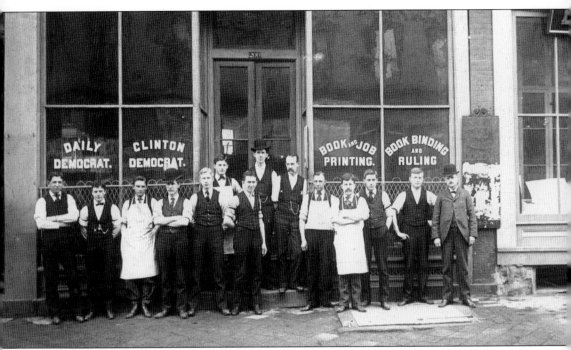

The staff of the *Clinton Democrat*, a newspaper that existed in Lock Haven from 1845 to 1921, poses in front of the paper's office. Identified in the photograph are, from left to right, Wesley Wagner, Clyde Daley, Allyn Rote, Charles Oberheim, Frank Fox, Harry Oberheim, Charles Herr, Will Mulhall, James Nobel, Order Morris, Frank Fisher, Frank Harvey, Ed Oberheim, and W. M. Robinson (editor). (Courtesy of the Clinton County Historical Society.)

Rebecca Gross, an outstanding professional who helped the success of the *Lock Haven Express* and became the paper's managing editor in 1931, is seen reading the paper in the photograph at right and in the newsroom in the lower photograph. She was a founding member of the Pennsylvania Women's Press Association and was the first female president of the Pennsylvania Society of Newspaper Editors. She also was a trustee of Lock Haven University and member of the Pennsylvania State System of Higher Education Board of Governors. She was not only known for the achievements she made, but also for a strange twist of fate. Ironically, Gross would lose both of her legs in an automobile crash just after composing a New Year's Eve editorial on driving safely. (Courtesy of the Annie Halenbake Ross Library.)

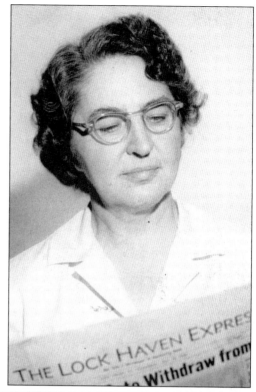

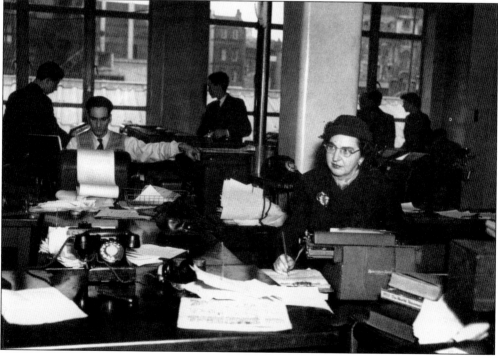

Nitsche's Meat Market was a familiar site in Lock Haven for many years, located on the corner of Main and Jay Streets. It was reported to be the first meat market in Lock Haven, seen here on June 3, 1886. The market was operated by John Nitsche and his son William, and the intersection where it was located was known as Nitsche's Corner for a number of years. (Courtesy of the Annie Halenbake Ross Library.)

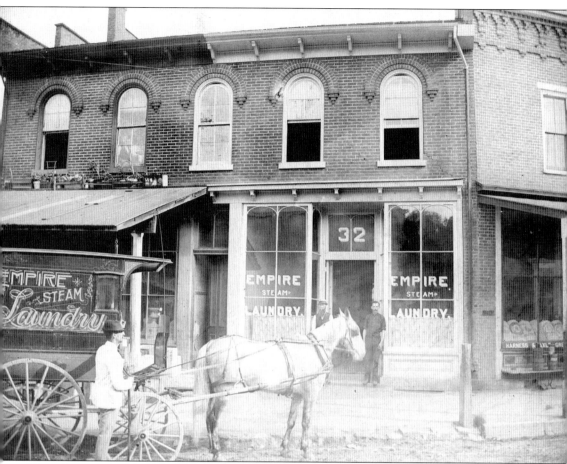

This photograph taken around 1900 shows the front facade of the Empire Steam Laundry building, Lock Haven, with delivery wagon and driver. Charles Mayer McGhee is in the foreground. Notice the rooftop garden in the upper left of the photograph. (Courtesy of the Annie Halenbake Ross Library.)

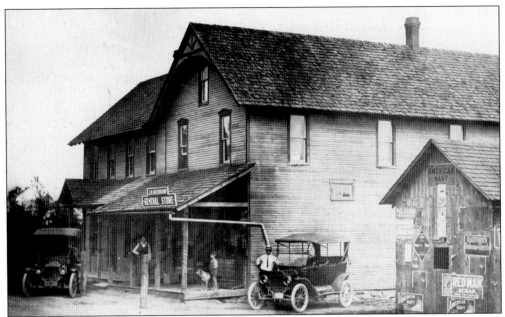

As Lock Haven and Mill Hall were centers to large enterprise and industry, many of the county's small towns had their own establishments, such as the J. H. Overdorf General Store in Carroll. General stores met the needs of the local people in many small towns where traveling to the city was labor intensive and time consuming. (Courtesy of the Annie Halenbake Ross Library.)

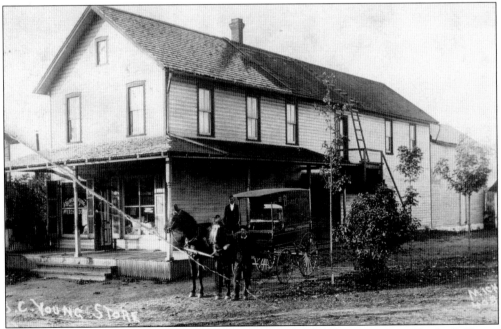

General stores also surfaced in locations where other activity was occurring. The B. C. Young Store in Youngdale was close to a stop of the Pennsylvania Railroad. In this undated photograph, it appears that the store had its own delivery service with a large wagon to carry goods. (Courtesy of the Annie Halenbake Ross Library.)

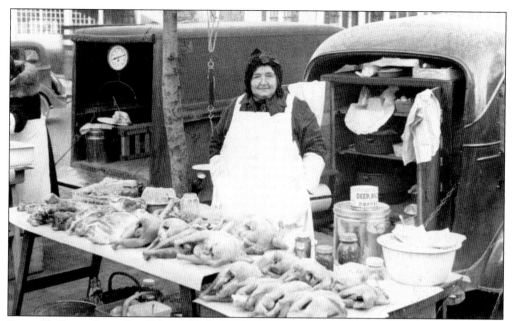

Betty Shilling, the wife of Harry Shilling of Clintondale, offers a wide variety of poultry for sale on December 24, 1940, at the Lock Haven curb market. It was reported that Betty rarely missed going to the market and was well known by those who frequented it. Betty butchered hogs every week, and people sought after her souse and liverwurst. (Courtesy of the Annie Halenbake Ross Library.)

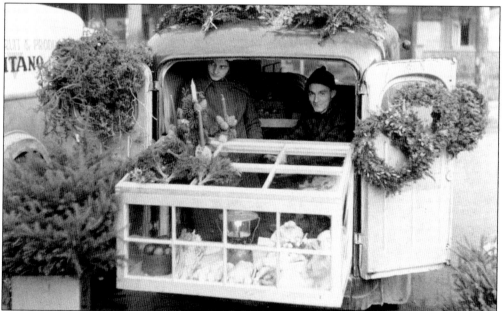

Charles Kreidler and his wife sell Christmas wreathes at the Lock Haven curb market on December 24, 1940. Curb markets in Lock Haven still enjoy popularity, as one is still held on weekends in the parking lot of the Clinton County Courthouse off of Main Street. These days, many Amish vendors bring their goods and produce for sale. (Courtesy of the Annie Halenbake Ross Library.)

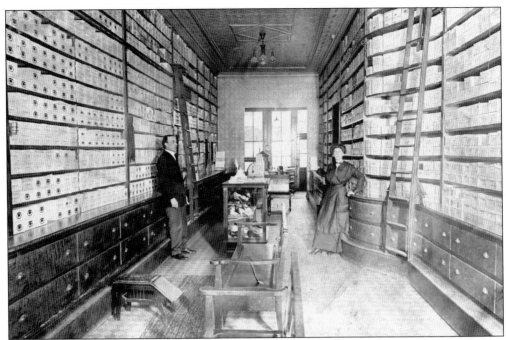

Shoeboxes are stacked to the ceiling along the entire length of this store in Lock Haven. John and Lillian Haberstroh look over their large inventory in Haberstroh's Shoe Store, 105 East Main Street, in this undated photograph. (Courtesy of the Annie Halenbake Ross Library.)

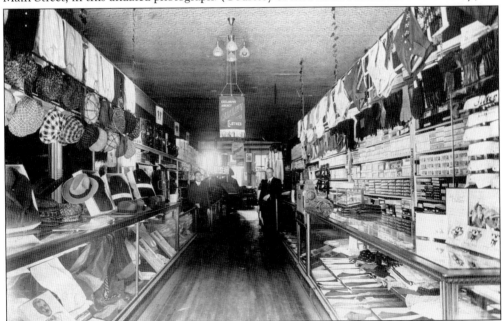

Israel S. Hurwitz and John Forsht stand in the Hurwitz store, once located at 127 East Main Street, in Lock Haven. The photograph was taken in 1917 and features men's fashion of the day, with a variety of driving and dress hats in the upper left of the photograph. The sign in the middle of the photograph reads, "Exclusive agency quality clothes." (Courtesy of the Annie Halenbake Ross Library.)

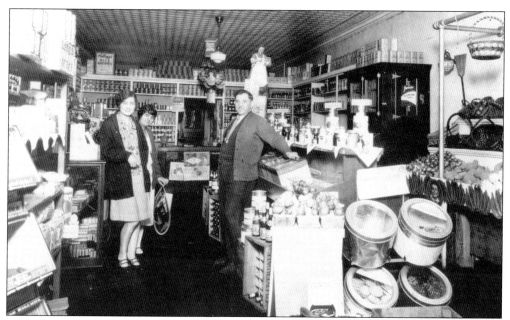

This photograph, taken in the late 1920s or early 1930s, shows the interior of the grocery store operated by Anthony Reitano. The store offered canned goods, fruits and vegetables, and bulk items for sale. Reitano had stores at two locations on Bellefonte Avenue by 1928. The three people in the photograph are, from left to right, Sara Archey, an unidentified woman, and Anthony Reitano. (Courtesy of the Annie Halenbake Ross Library.)

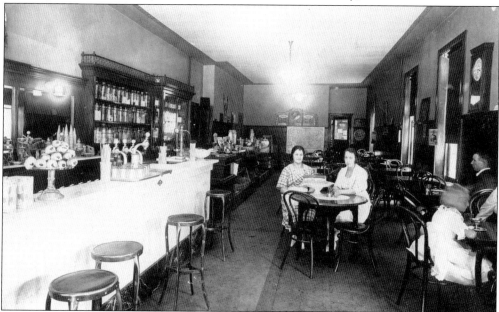

The Achenbach and Son's Soda Fountain store in Lock Haven, seen in this photograph taken around 1910, was a favorite stop for ice cream, fountain sodas, candy, and conversation. The first ice-cream soda was invented in 1874, and in 1903, pull fountains became available. Soda fountains were widely popular up until the 1960s. The popularity of soda fountains declined with the invention of fast-food restaurants. (Courtesy of the Annie Halenbake Ross Library.)

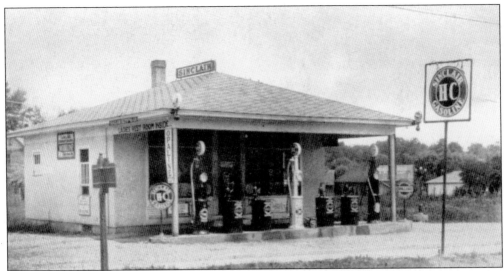

Heller's Gas Station in Avis is seen here around 1926, offering the Sinclair brand of gasoline and a ladies' restroom inside. Gas stations that offer full service like Heller's did at the time of this photograph still exist, although they are largely a thing of the past. Although the gasoline company still exists, the Sinclair brand is not sold in Clinton County anymore. (Courtesy of the Annie Halenbake Ross Library.)

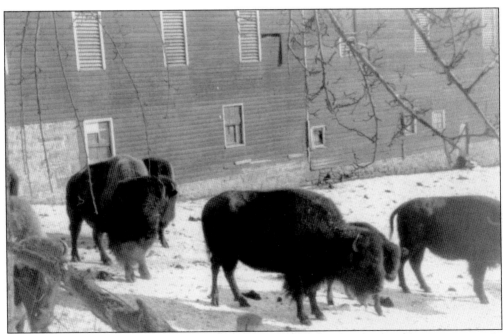

The Buffalo Inn, once located three miles east of Lock Haven, was a popular restaurant for tourists and locals alike. The back of a 1961 postcard from the inn reads, "Delicious fresh foods of all types served daily. Buffalo steaks and burgers a special treat. See buffalo herd in natural habitat. Cars serviced by trained attendants while you dine. Tourist information." (Courtesy of the Annie Halenbake Ross Library.)

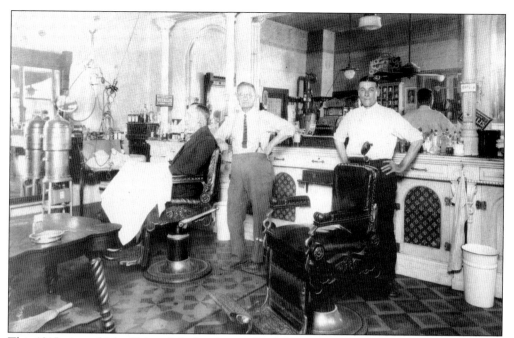

This 1915 view of Jake Heimer's barbershop in Lock Haven was taken after the shop had been remodeled. Notice the ornate designs made out of metal on the sides and the bases of the barber chairs, and the ornate metal cash register. In the upper left, there is a tangle of electrical wiring. (Courtesy of the Annie Halenbake Ross Library.)

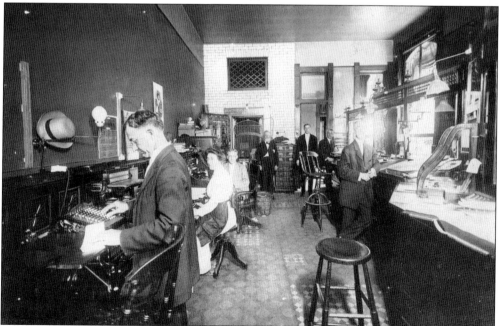

Employees are seen at work in the office of the First National Bank in Lock Haven on September 9, 1912. Office workers include Harry Geary, Mary Lelotte, and Fenton Fredericks. Others in the photograph are unidentified. The man at left operates an adding machine, and in front of him on the counter are three clocks. (Courtesy of the Annie Halenbake Ross Library.)

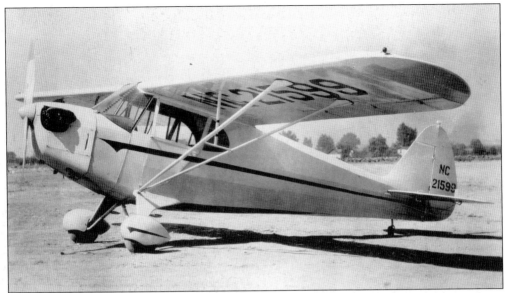

The J-4 Coupe Piper Cub, in the photograph above, was produced in Lock Haven by the Piper Aircraft Corporation, founded by William T. Piper in 1937. Over 5,000 Cubs went to the armed services during World War II. Piper Aircraft would eventually offer 29 models of planes for a variety of purposes that ranged from agricultural use to personal flying. The photograph below shows the 1962 board of directors for the company, which oversaw operations for around 4,000 employees. The company suffered $23 million in damage from flooding in 1972 and had a difficult time recovering. It closed its Lock Haven facility in 1984. (Courtesy of the Annie Halenbake Ross Library.)

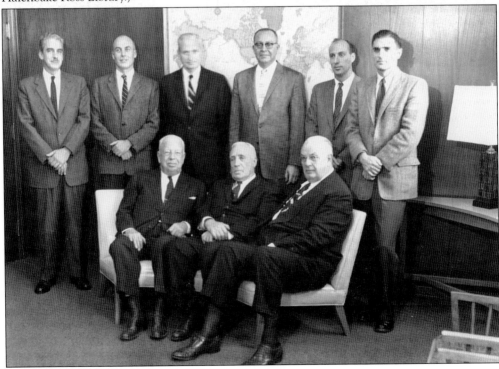

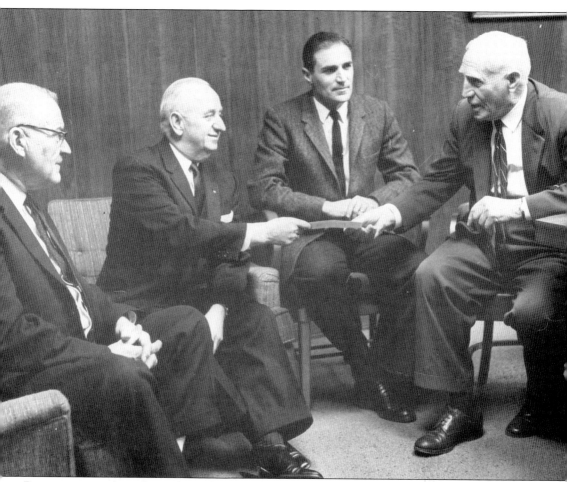

Representatives from Piper Aircraft Corporation pass a check to support the Lock Haven YMCA. It is the success of local business and industry that helps ensure the success of local civic organizations, as business is often willing to directly support charity. In the photograph, from left to right, are J. F. "Pop" Puderbaugh, Henry Angus, Tony Piper, and W. J. Piper Sr. (Courtesy of the Annie Halenbake Ross Library.)

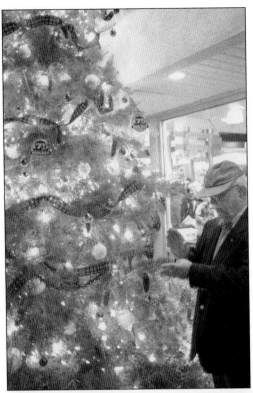

John Rich VI, a descendent of the John Rich who founded Woolrich, Inc., claps after he signaled the lighting of the Christmas tree in front of the Woolrich Company Store in Woolrich, marking the company's 175th anniversary in 2005. The company honored the over 600 people who worked for it by holding the annual holiday open house for employees on November 18, 2005. "My father always said, 'As long as we have one brick upon another, our employees are first,'" Rich said at the gathering. (Author's collection.)

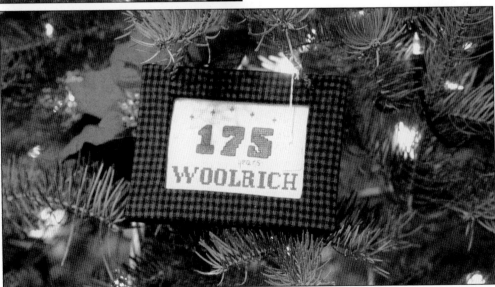

The Woolrich Company Store Christmas tree was adorned with ornaments made by employees in honor of Woolrich's 175th anniversary. The ornaments are made out of swatches of wool from the mills, and in 2005, the swatches were red and black in honor of the company's anniversary milestone. A baked goods contest also was held. Employees sampled free holiday treats, and outside of the store they roasted s'mores and ate kettle corn. According to Rick Insley, senior vice president, the gathering was a chance to honor employees right before the company headed into its busy holiday season. (Author's collection.)

Four

The Evolution of Education

Children of the early settlers learned to read and write at home, depending on the wishes of their parents. Places of worship also helped with educational instruction before the emergence of public schools.

The first reported schoolhouse was built in the Pine Creek area in 1774, and others eventually came on the scene after the Revolutionary War when the Second Stanwix Treaty would allow for secure settlement. The first schools were constructed out of logs and mostly cropped up in areas that were easily accessible. The State Education Act of 1834 brought about a formal system with a county superintendent, and by the 1860s, the county had nearly 90 schools.

Higher education came to the county after the commonwealth passed the Normal School Act of 1857, responsible for the establishment of 14 campuses across Pennsylvania. The Central State Normal School, now known as Lock Haven University, was founded in 1870 and opened its doors for instruction in 1877. Although the university continues to train qualified teachers, it also provides a comprehensive liberal arts curriculum.

Education has always been a primary concern of the residents of Clinton County. Where modernization has brought about new opportunities and technological advances, it also is responsible for the consolidation and the closure of rural schools. To this day, school closures are a topic of debate and a continuing reality for area residents in the Keystone Central School District, as all school districts in Pennsylvania struggle to receive financial support for improvements.

The Glen Union School was a wood frame, one-room school built around 1900 in Grugan Township. It is located on the east bank of the West Branch of the Susquehanna River, approximately 1.4 miles below the mouth of Rattlesnake Run. William Grugan sold the land to the local school district. The Glen Union School was attended by children of approximately 30 families. Some traveled to school by train, as Glen Union was then a railroad town. Betty Baird, later the assistant county superintendent of schools, began her teaching career here in 1912. (Courtesy of the Annie Halenbake Ross Library.)

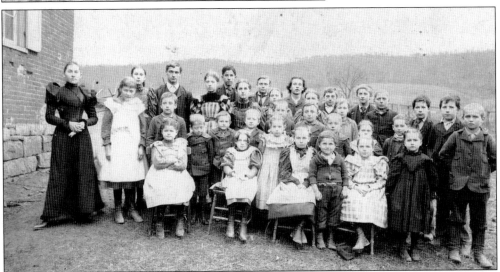

This group portrait of the East End Nittany Valley School was taken around 1900. Included here are Corinne Snyder (teacher), Estella Brumgard, Byron Ricker, Newton Krebs, Forence Barner, Blanche Moore, Blanche Krebs, Jimmie Treaster, Bertha Edgar, Estella Courter, Roy Emerick, Eva Ricker, David Corter, Cora Ricker, Mayme Barner, Margaret Corter, Clarence Moore, Lloyd Krebs, Roy Brumgard, Sadie Brumgard, Norah Furst, Luther Paul, Louden Brumgard, Joseph Brumgard, Florence Snyder, Jay Wesley Barner, William Brumgard, Luther Krebs, Lewis Frantz, Edward Corter, John Brumgard, and Clyde Ricker. Pinafores for little girls were proper attire. (Courtesy of the Annie Halenbake Ross Library.)

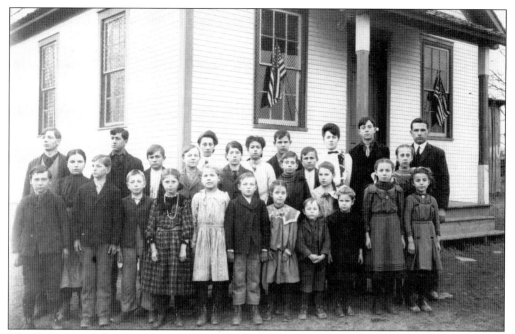

The Rosecrans School in Sugar Valley, also known as the "Sheets" or "Sheats" school, is seen here around 1905. The teacher of the one-room schoolhouse is George W. Meyer, seen to the right of the children. For the photograph, two American flags were put on the front windows of the schoolhouse. (Courtesy of the Annie Halenbake Ross Library.)

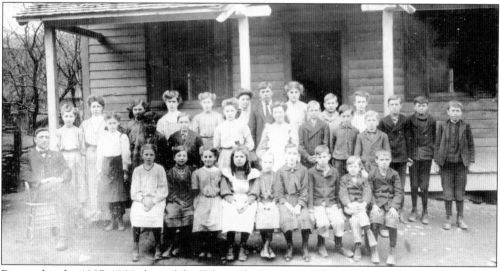

Pictured is the 1907–1908 class of the Tylersville Grammar School. The teacher was Newton L. Bartges. He eventually became the county superintendent of schools. Pictured are, from left to right, (first row, seated) Newton Bartges, Emily Shaffer, Tillie Weaver, Mabel Eyer, Mary Barner, May Smith, Alva Bressler, Aaron Grieb, Harry Bletz, and Beecher Grenninger; (second row) Beatrice Frantz, Bright Bletz, Sam Smith, Helen Miller, Helen Miles, Landas Greninger, Nevin Grieb, and Roger Shaffer; (third row) Ruth Barner, Ruth Meckley, Lulu Karstetter, Miriam Miller, Fairy Shaffer, Mina Miller, Roy Weaver, Annie Weaver, Clarence Smith, Annie Caris, Torrence Miller, Eldon Ilgen, and Charles Barner. (Courtesy of the Annie Halenbake Ross Library.)

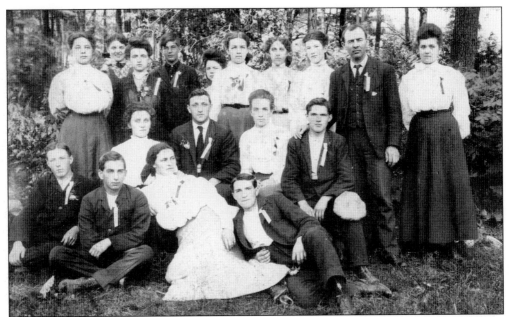

R. F. Smith, second from right, was the teacher at the time of this photograph of the Loganton Normal School taken in 1907. Rural schools in Clinton County were developed in the early 20th century, and by 1905, there were over 5,000 students enrolled in 154 schools. During this period, many of the one-room schools were modernized and received new furniture and supplies. (Courtesy of the Annie Halenbake Ross Library.)

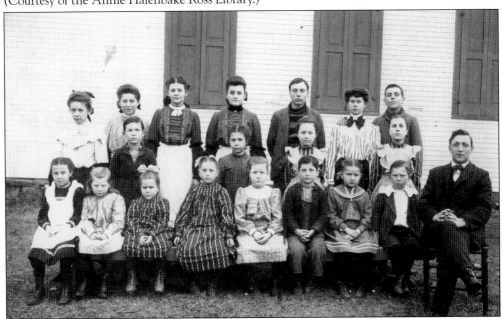

Students of the Womeldorf School in Sugar Valley pose for a photograph during the 1904–1905 school year. Newton L. Bartges, who would later become the superintendent of Clinton County schools, is the teacher seated at right. The two girls in the front row who are third and fourth from the left must be sisters as they are wearing the same patterned dresses and both have bows tied in their hair. (Courtesy of the Annie Halenbake Ross Library.)

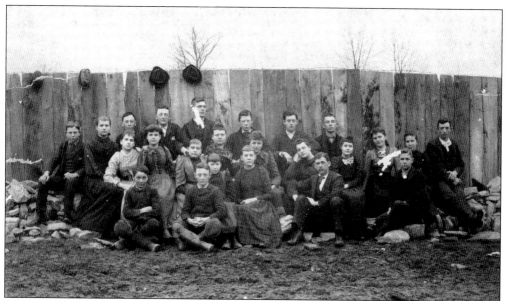

The senior class of Salona High School is seen here on January 1, 1891. In the first row, from left to right, are Miner Miller, Edward Esenwine, teacher Lou Fulton, and W. A. Snyder, who later became the county superintendent of schools. In the second row, among several who are unidentified, are Edith Stoner, Nell Herr, Annie Sigmund, Floy Sweely, Annie Miller, Josephine Wilson, J. D. Allison, Kate Stoner, Bud Krape, and Torrence Kessinger. In the third row are Claude Herr, Mabel Sweely, Charles Miller, William Esenwine, Charles Krape, and Charles Herr. (Courtesy of the Annie Halenbake Ross Library.)

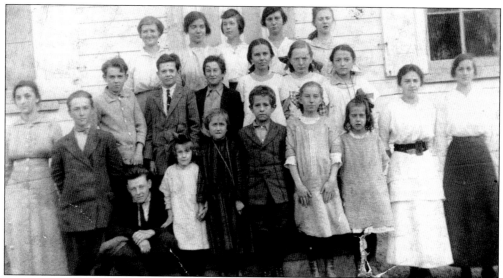

The 1916 McElhattan School is pictured here during the time of World War I. After the school's closure, the building was used as a place to grind feed. Identified in the photograph but not matched are Hazel Shurr, Florence Page, Florence Shurr, Mabel Rall, Sara Phillips, Madalyn Wright, Naomi Phillips, Florence McGuire, Orrie Shurr, Tesla Ricker, George Hickoff, Charles Fritz, Othmar Young, Ardath McCloskey, Maxine Shurr, Gene Ricker, Faye Shurr, Reba McCloskey, Pearl Quiggle, and Lena Iler. (Courtesy of the Annie Halenbake Ross Library.)

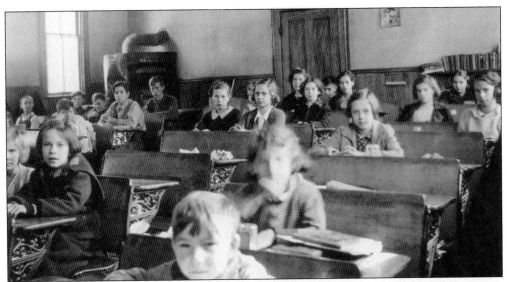

The Springer School was a one-room schoolhouse built around 1890 near Haneyville on Route 664. The deed for the property was transferred to Gallagher Township on March 1, 1889. Frankton L. Swartz sold the land for $15. During that year, all of the teachers in the township were women, who were making $24 a month and teaching six months a year. The classrooms had an average of 38 students, and it cost the district $1.08 a month per student to run the school. The school was shut down in 1955. (Courtesy of the Annie Halenbake Ross Library.)

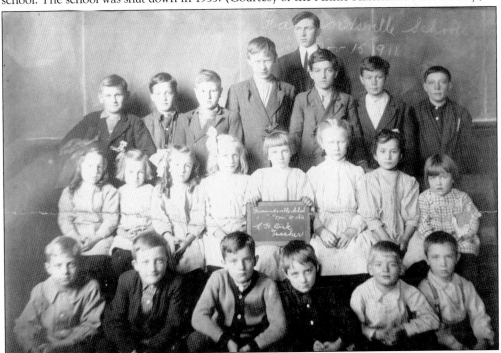

Taken on November 15, 1911, this is a group portrait of the students of the Farrandsville School. Included in the photograph are teacher Roy H. Dick, Robert Kniss, and his brother, Grant. Others are unidentified. Dick had 21 students to attend to in the one-room schoolhouse. (Courtesy of the Annie Halenbake Ross Library.)

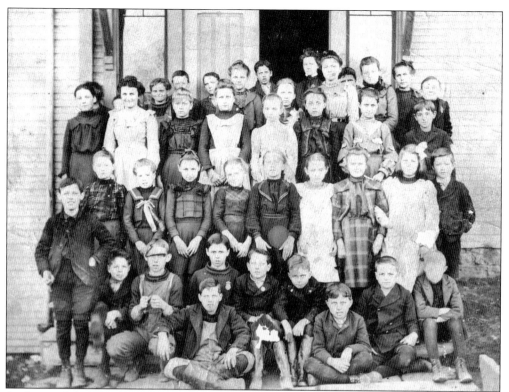

Students of the Flemington Grammar School are seen on March 25, 1902. The school was taught by Laura Leitzell. The group includes Frank Long, Mack Stouck, Ellery Campbell, Clyde Campbell, Clarence Kelsey, Fred Maggs, Ralph Vanatta, Charles Stiver, Norman Porter, Schuyler Gray, Burt Gummo, George Rhine, John Knarr, Olive Moore, Clarence Narehood, Rachael Clark, Grace Knarr, Torrence Fisher, Mary Sheasley, Bess Wasson, and James Wasson. (Courtesy of the Annie Halenbake Ross Library.)

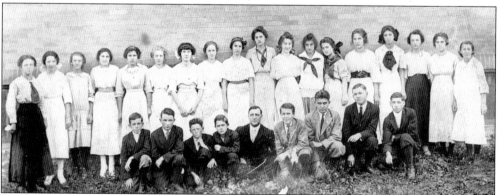

Avis High School students are dressed in their finest for this 1912 photograph. Newton L. Bartges was the school's principal. Pictured from left to right are (first row) Clair Hastings, Robert Bartley, Grant "Red" Miller, Seba Bartley, Newton Bartges, Gerald Lanks, Firman Spong, John Johnson, and John Bitner; (second row) unidentified teacher, Annabel Bussler, Lillian Sands, Ruby Henry, Reba Emery, Abigail Kline, Jessie Bartley, Grace Kline, Hester Heller, Martha Stamm, Florence Brickley, Sara Kagle, Mary Stamm, Dorothy Spong, Emma Miller, ? Herman, Ruth Campbell, and Grace Bitner. (Courtesy of the Annie Halenbake Ross Library.)

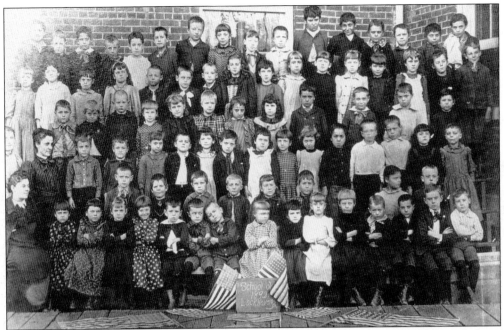

Students from the Third Ward Church School of Lock Haven have a piece of slate in front of them along with different sizes of American flags. Written on the slate in chalk, it says, "School of 1892, Lock Haven, Pa." It appears that the children in the first row must have been told by their teacher to cross their arms. (Courtesy of the Annie Halenbake Ross Library.)

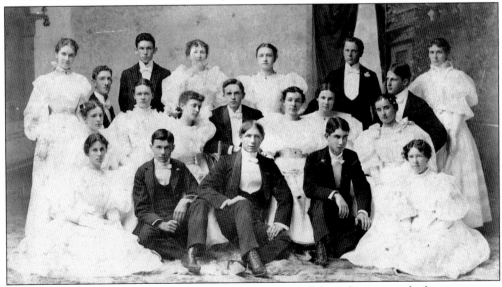

The Lock Haven High School class of 1896 is seen in full formal attire, with the young men wearing tuxedos and the young women wearing white dresses. From left to right are (first row) Helen Prendigle, Harry S. Bittner, Clarence Waymouth, Warren Wynn, and Bertha McKerney; (second row) Sarah Gibb, Ada Frank, Annie Fisher, Palmer Loveland, Joespine Leiser, Loretta Prendigle, and Mabel Robb; (third row) Helen Hiller, David Welch, John Monette, Nettie Schofield, Lou Schrettler, Bertram McLees, Hester Kintzing, and Mary Mason. (Courtesy of the Annie Halenbake Ross Library.)

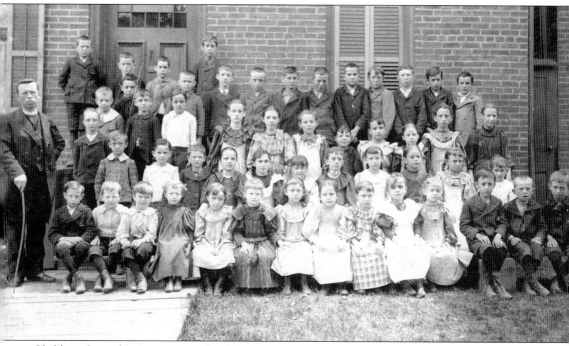

Children from the St. Agnes School, known today as the Lock Haven Catholic School, are seen at the school's location on West Water Street in this photograph taken around 1900. The children in the photograph have incentive to behave for the photographer as the priest on the left stands holding a switch. The St. Agnes parish, originally established by German Catholic residents, has existed in Lock Haven since 1870 and is still in operation today. (Courtesy of the Annie Halenbake Ross Library.)

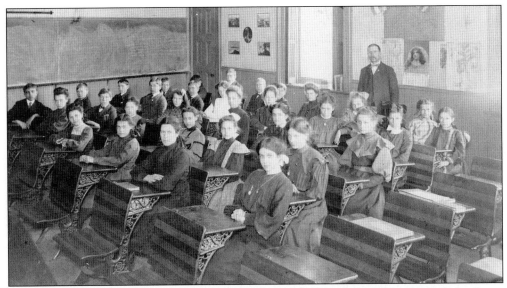

The 1905 class photograph of the Third Ward Grammar School, Lock Haven, includes Bruce Kreamer, William Hall, Bert Stevenson, Henry Bender, Lyol Bush, Marcus Hall, Blair Klepper, Helen Geary, Ned Wagner, Ed Miller, Florence Kaufman, Gertrude Ubil, Elizabeth Walters, Carrie McCloskey, Vera Gardner, Helen Kintzing, Helen Welliver, Mary Ritman, Beatrice Huber, Kathryn Harris, Gertrude Marr, Lena Lose, Edith Warner, Nell Burrows, Florence Bickford, Florence Candor, Ruth Pursley, Agnes Hamilton, Viola Sohmer, and Edna Batchelder. (Courtesy of the Annie Halenbake Ross Library.)

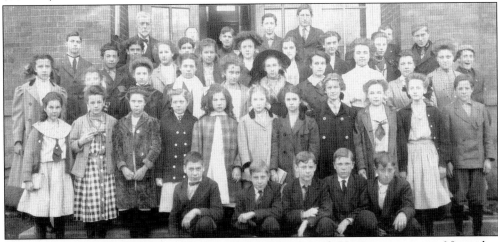

The seventh and eighth grades of the First Ward School, Lock Haven, are seen on November 15, 1909. From left to right are (first row) Harold Dorey, Richard Seltzer, Joseph Hanna, Ward Farwell, and Philip Myers; (second row) Esther Myers, Amy Hanna, Miriam Probst, Elma Lucas, Ethel Brown, Helen Bowser, Elizabeth Smith, Elizabeth Kemmerer, Martha Best, Miriam Winters, and Robert McCloskey; (third row) Ruth Bartley, Sue Rich, Ethel Masters, Ruth Karstetter, Anna Painter, Marguerite Vallance, Mary Brady, Edna Thornton, Amy Peeling, and Margaret Beck; (fifth row) D. M. Brungard, Dale Reeder, Paul Klepper, John Caskey, Forrest Remick, and Clarence Winters. The fourth row includes Marlin Motter, Fred Myers, ? Hurst, Ruth Scheid, Effie McKenzie, Alta Hamlin, Margaret Keller, Azella Caskey, Harold Oberheim, and Carl Smith. (Courtesy of the Annie Halenbake Ross Library.)

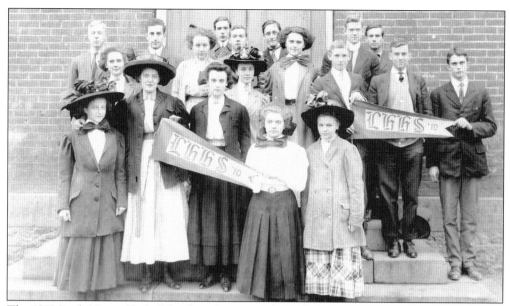

The 1910 Lock Haven High School graduates are dressed up and holding pennants, with many of the young ladies wearing ornate hats. The students, from left to right, are (first row) Eleanor Seltzer, Ethel Probst, Gladys Lyon, Lilian Harvey Pletcher, and Edith Lawrence; (second row) Anna Klepper, Ruby Kress, Annabel Breesler, Anna Waite, Robert Myers, Charles Scheid and Hayes Shaffer; (third row) New Wagner, Joel Claster, Clarence Wilson, Early Quinlan, Sharon McCloskey, Harry Swope, and Frank Baird. (Courtesy of the Annie Halenbake Ross Library.)

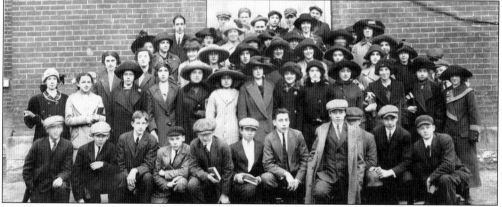

The Lock Haven High School freshmen class in 1915 is seen in formal winter attire. Pictured from left to right are (first row) John Mader, Clinton Probst, Daryl Rea, Charles Schadt, Stanley Furst, Elmer Reeder, Harold Dorey, Ellis White, Dean Gardner, Dean Schwarz, and William Johnson; (second row) Verna Bennet, Jennie Gibson, Elma Lucas, Helen Toot, Lola Glossner, Anna Johnson, Marion Smith, Frieda Bauman, Kathryn O'Connel, Lucy Salvia, Helen Dubler, Kathryn Lichtenwalner, and Helen Coffey; (third row) Alta Hamlin, Jennie Hanna, Elizabeth Kemmerer, Ruth Bartley, Genevive Brosius, Mary Ralph, Anna Shoemaker, Elizabeth Sack, Ida Nolan, George Baird, and Karl Keller; (fourth row) Stella Stark, Jessie Bentley, Florence Fox, Helen Grove, Ada Weaver, Marguerite Vallance, Miriam Probst, Marie Marshall, and Miriam Bottorf; (fifth row) Lester Keller, Carrie Packer, Eleanor Ritter, Paul Simon, Azella Caskey, and Helen Dahl; (sixth row) Harper Bathurst, Lewis Rathgeber, Samuel Kessinger, Frances Smith, and William Courtney. (Courtesy of the Annie Halenbake Ross Library.)

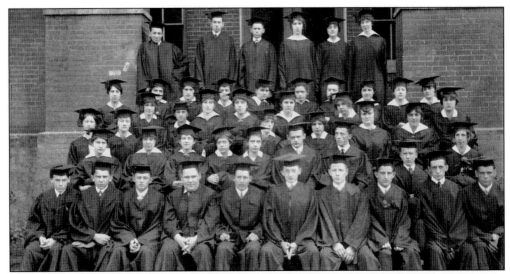

The Lock Haven High School class of 1915 poses in cap and gown. Pictured here from left to right are (first row) Charles Schadt, Clinton Probst, William Johnson, Paul Simon, William Courtney, Stanley Furst, Francis Smith, Daryl Rea, Lester Keller, and George Baird; (second row) Anna Johnson, Miriam Probst, Jennie Gibson, Elma Lucas, Kathryn Lichtenwalmer, Lews Rathgeber, John Mader, Guy Cawley, and Verna Bennett; (third row) Stella Stark, Carrie Packer, Kathryn O'Connell, Miriam Bottorf, Helen Dahl, and Genevieve Brosius; (sixth row) Ellis White, Elmer Reeder, Carl Keller, Helen Toot, Jennie Hanna, and Azella Caskey. Graduates identified in the fourth and fifth rows include Marie Marshall, Ada Weaver, Winifred Miller, Ruth Bartley, Jean Shaffer, Marzella Rummer, Marion Smith, Eleanor Ritter, Helen Grover, Alta Hamlin, Elizabeth Sack, Helen Good, Anna Shoemaker, Lola Glossner, Jessie Bentley, and Florence Fox. (Courtesy of the Annie Halenbake Ross Library.)

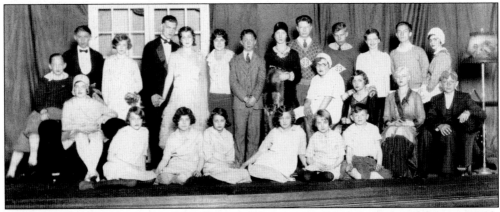

The freshman class play in the 1929–1930 school year at Lock Haven High School was *Daddy Long Legs*. The children in the front row were a year or two younger than the rest of the students and took the parts of the children in the orphanage. From left to right are (first row) Barbara Furst Parkinson, Grace Mary, Eleanor High Farrington, Ida Fromm, unknown, and Wayne Rathgeber; (second row, seated on chairs) Richard Hoy, Hannah Mervine Miles, Blanche Hoberman Crane, Elsie Bentz Harris, Helen Reed Munro, and Gerard Petrucci; (third row) Harris Lipez, Marion Brown Lucas, Harvey Troutman, Audrey Bower, Ruth Hendricks, Harry R. Callahan Jr., LaWave Underwood, Roy Schuyler, unknown, Sarah O'Reilly Loria, Louis Coira, and Margie Griffith. (Courtesy of the Annie Halenbake Ross Library.)

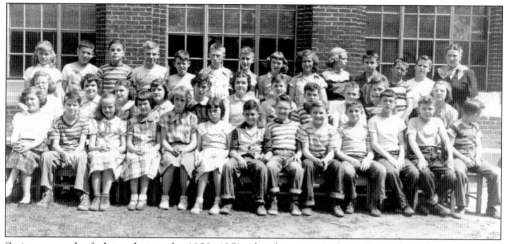

Stripes were the fashion during the 1950–1951 school year as sixth-grade students from Roosevelt Elementary, Lock Haven, pose for a photograph. Pictured, from left to right, are (first row) Mary Jusick, Richard Grenniger, Rebecca Wetzel, Elaine Bierly, Judy Kramer, June Frazier, Dean Schmidt, Paul McCloskey, Bobby Englert, Gary Wooding, Charles Simcox, John Eckel, and Gary Bilby; (second row) Donna Herman, Sylvia Balis, Patty Dullen, Ruth Ann Thomas, Opal McGhee Wert, Judy Long, Robert Schetrompf, Duwayne Miller, Robert Mitchell, David Wolf, and Barbara Geyer; (third row) Carol Barnhart, Jim Grenninger, Richard Renzo, David Grimm, Mike Dice, Ronald Kling, Robert Klewans, Janice Frank, Lorette Johnson, Meda Stevens, Robert Forney, John Wert, Raphael Edmonston, and Frances Mye. (Courtesy of the Annie Halenbake Ross Library.)

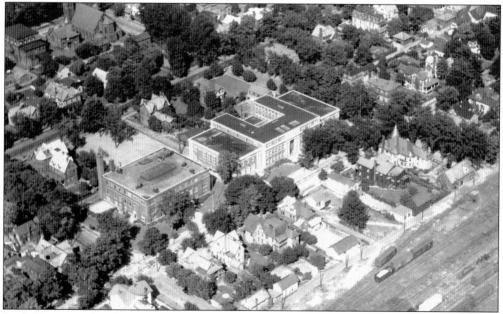

Lock Haven High School, on West Church Street, is seen in this aerial photograph taken in the 1970s. The building was sold to Lock Haven University after the Keystone Central School District constructed a new high school in Mill Hall. The university, formerly known as the Central State Normal School, holds classes and houses offices at the building, which is now known as East Campus. (Courtesy of the Annie Halenbake Ross Library.)

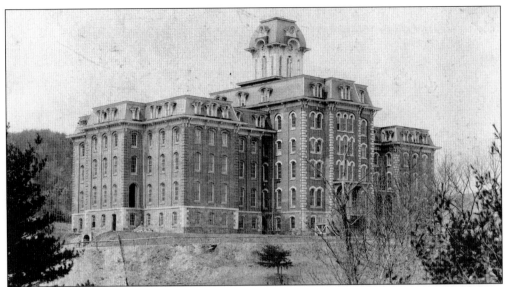

Price Hall, the original building of the Central State Normal School seen in the above photograph, was built in Lock Haven in 1877, and it was destroyed by fire only 11 years later on December 8, 1888. The lower photograph shows "Old Main," which was the main building of the campus for many years. The Central State Normal School was founded under the Normal School Act of 1857 as one of the regional centers to train teachers in the commonwealth of Pennsylvania. It initially offered a two-year program but began conferring four-year degrees in 1927 when the name of the school was changed to the State Teachers College at Lock Haven. Today, as Lock Haven University, the school offers a full array of liberal arts degrees, as well as graduate degrees in education, liberal arts, and the physician assistant discipline. The school currently enrolls over 5,000 students between its main and Clearfield branch campuses. (Courtesy of the Annie Halenbake Ross Library.)

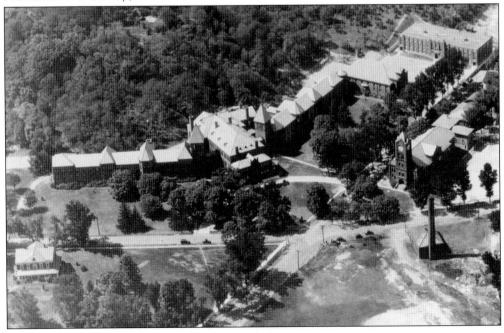

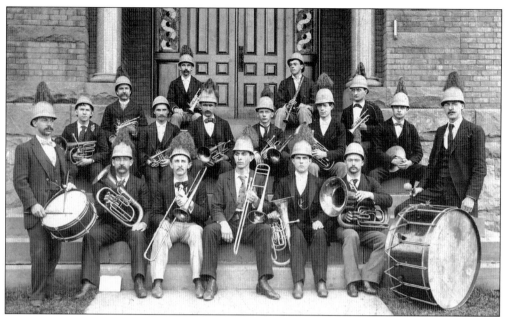

Members of the Central State Normal School band are seen in their uniforms in 1895. The catalog of the Central State Normal School for that year describes what it takes to be in the band: "Pupils, when tolerably proficient upon the violin, cornet or other instruments, will have the privilege of playing in the 'Normal Orchestra,' which will be organized during the school year. Students desiring a musical education will have the same advantage here as at the conservatories of Germany, the system taught being that of the best school—'Stuttgart Conservatory,' Germany. The course will consist of four grades. Diplomas will be awarded to students having finished fourth grade, which includes music from all the great masters, Beethoven, Mozart, Bach, Liszt, Chopin, Mendelssohn, Rubinstein and others." (Courtesy of the Lock Haven University Archive.)

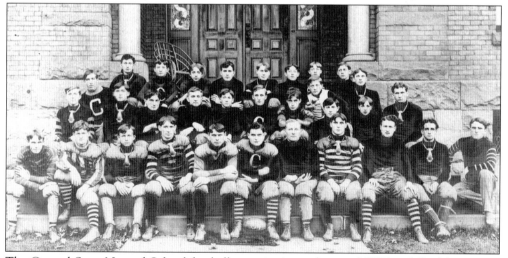

The Central State Normal School football team is pictured around 1905 in full athletic attire on the steps of Old Main. Athletics have always been popular at the school, and today the university boasts two NCAA Division I teams with its women's field hockey and men's wrestling programs. (Courtesy of the Annie Halenbake Ross Library.)

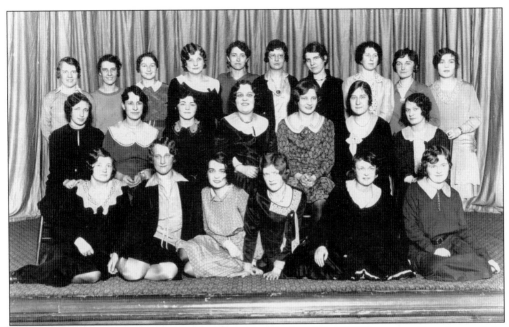

The State Teachers College of Lock Haven's women's glee club of 1930 was considered one of the most active and representative organizations of the college that year, according to the student yearbook. Until the fall term of 1929, the club was composed of members from each class. But in 1929, the membership was limited to seniors. Students interested in being a part of the glee club had to go through a voice test, and each member pledged to attend all concerts, take part in chapel singing, and "promote and develop music appreciation." The glee club offered a program during Sunday vesper services at the school, took part in carol singing around Christmas, and annually gave a musical operetta. (Courtesy of the Lock Haven University Archive.)

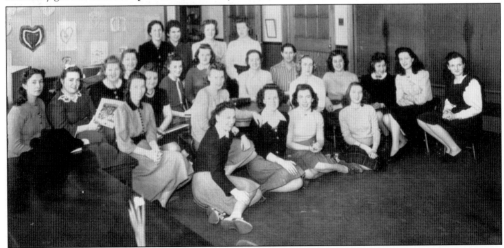

The Association for Childhood Education club of the State Teacher's College of Lock Haven is seen in 1941. The requirement to be a member was to have an interest in the education of young children, and the club was affiliated with national education organizations. The State Teacher's College of Lock Haven, now Lock Haven University, was primarily a college to prepare teachers at its foundation in 1870 as the Central State Normal School. (Courtesy of the Lock Haven University Archive.)

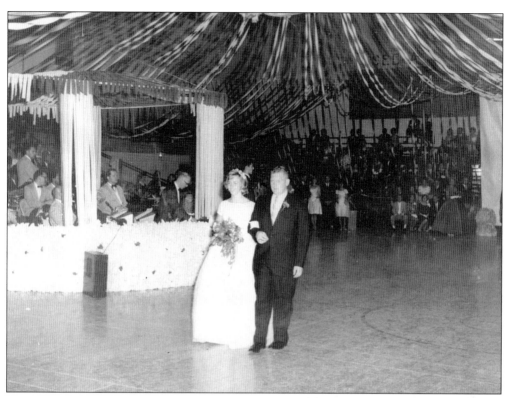

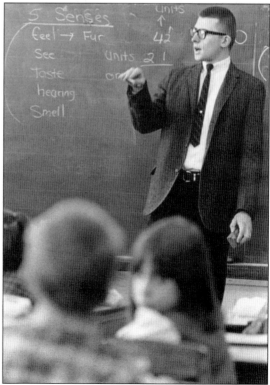

Lock Haven State College homecoming queen Virginia Blake is escorted by Jason Marzo in 1962 in the photograph above. Homecoming activities are still a favorite annual event at Lock Haven University. The name of the school was changed from State Teachers College of Lock Haven to Lock Haven State College in 1960, although the school continued and still continues to train teachers for employment in the state's primary and secondary schools. The photograph at right, used in a Lock Haven State College student teaching handbook, shows a student teacher conducting a class in 1967. (Courtesy of the Lock Haven University Archive.)

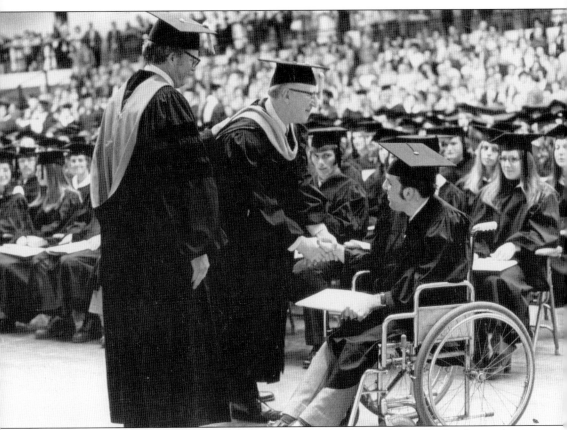

Dr. Francis Hamblin and Dr. Gerald Robinson congratulate Darwin Ziegler for graduating during the 1974 commencement of Lock Haven State College. Lock Haven University, which underwent the change to that name in 1983, now confers close to 1,000 degrees annually. There are currently around 18,000 university alumni around the country and abroad. (Courtesy of the Lock Haven University Archive.)

Five

CALL TO SERVICE

A strong sense of service has always existed in Clinton County. The county has been home to veterans from every U.S. war and conflict dating back to the Revolutionary War, and veterans have always enjoyed a high level of support from area residents and organizations.

Over the years, various individuals have stepped forward out of civic duty to staff the municipal boards and councils. These people are largely responsible for the way the county has developed and the way it is today. One such person is George B. Stevenson, who was a local postmaster and mayor and who would eventually serve on the Pennsylvania State Senate from 1939 to 1962. Stevenson championed a system of dams along the West Branch of the Susquehanna River to help the region with flood protection.

The county also has always had a strong group of volunteer firefighters and emergency personnel who have been willing to come forward and assist others in times of need. In times of widespread emergency, such as the periods of flooding that have hit the area, these individuals have saved countless lives. They have helped the victims pick up the pieces after their homes and businesses have been destroyed. And they have prevented fires from doing greater damage than they could.

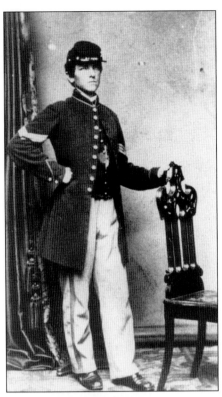

Reuben W. Schell of Lock Haven was one of the Clinton County men to serve in the Civil War. Schell was a member of Capt. C. H. Lyman's Lock Haven rifle guards, which eventually became Company D of the 7th Pennsylvania Reserves. The company took part in the second Bull Run engagement. Schell was a prisoner of war when he was captured in 1864, and he spent 10 months in Confederate prisons. (Courtesy of the Annie Halenbake Ross Library.)

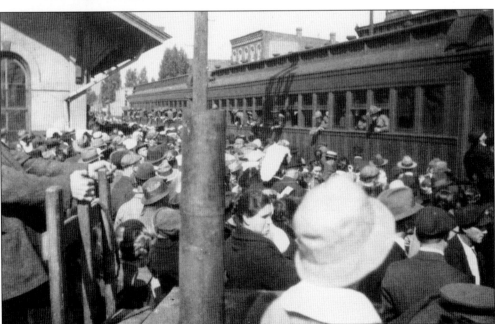

The community came out in full force for a farewell demonstration for the troops leaving from Lock Haven for World War I in 1917. U.S. Army Troop K of Lock Haven departed from the Pennsylvania Railroad station on Washington Street to head off to Europe and fight the German forces. (Courtesy of the Annie Halenbake Ross Library.)

A Liberty Loan Day parade was held on Main Street, Lock Haven, in 1917. The parades were to raise money for the war effort against Germany during World War I. In the photograph, nurses carrying a large red cross on a banner march down in front of a large crowd. (Courtesy of the Annie Halenbake Ross Library.)

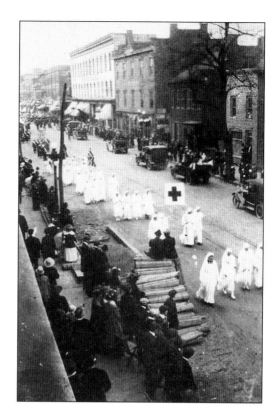

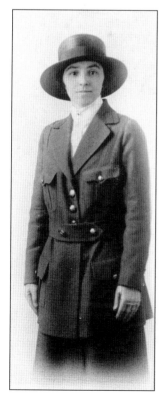

Wars change people's lives, as the war with Germany did with Maude (Albright) Moquin, who met her husband Raoul while on duty in the French war zones during World War I. She is shown in the nurse uniform she wore during her service abroad. After the death of her French husband, she remarried. (Courtesy of the Annie Halenbake Ross Library.)

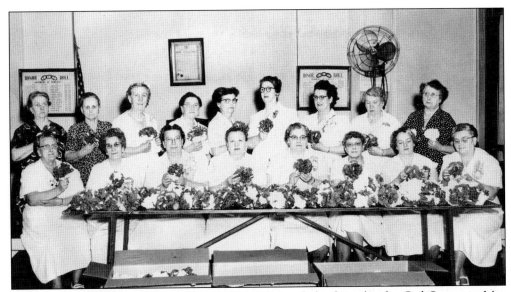

The American War Mothers of Clinton County were helped out by the Girl Scouts in May 1953 as Mother's Day carnations were sold to benefit veterans in area hospitals. The collected money was used for necessities for men in hospitals, as well as for entertainment. Pictured from left to right are (seated) Edna Rager, May McGhee, Katie Miller, Sarah Kemmerer, Margaret Fague, Elizabeth Watkins, Grant Hahn, and Mrs. Ray Miller; (standing) Mrs. Rorie Jodum, Mazie Eggler, Florence McDermit, Sara Hardy, Edna Caris, Nora Dershem, Thelma Munro, Bessie Rote, and Eleanor Scheid. (Courtesy of the Annie Halenbake Ross Library.)

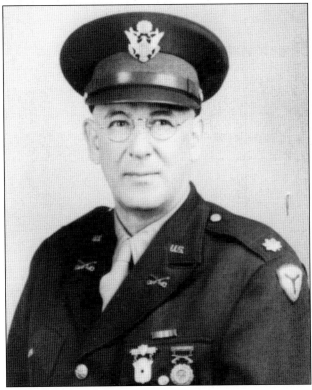

Many from Clinton County have been proud to serve, including Capt. Robert Cunningham Wallace, who died at the age of 73 in 1963. He lived in North Bend and died in Renovo Hospital. Wallace came to western Clinton County in 1933 as company commander of the Dyer Farm CCC Camp and later commanded the Hyner CCC Camp through its closing days. His army career included overseas service in World War I with the first regiment called into action. He was cited by Gen. John J. Pershing for "exceptional and conspicuous meritorious service." He earned the distinguished marksman's medal and went on to serve in World War II. (Courtesy of the Annie Halenbake Ross Library.)

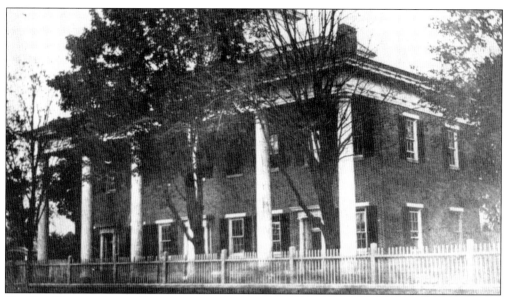

The first Clinton County Courthouse was built in 1842, seen here, on the corner of East Church and Henderson Streets. Lock Haven officially became the Clinton County seat in 1844, some five years after the county was formed. The first session of court was held in 1839 at Barker's Tavern in Lock Haven. A new courthouse was dedicated in 1869 and is still in use today at the corner of Jay and Water Streets. (Courtesy of the Annie Halenbake Ross Library.)

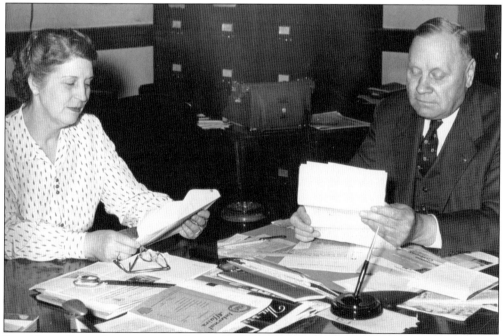

Republican Pennsylvania senator George B. Stevenson looks through a volume of mail on his desk along with an assistant in this undated photograph. Stevenson was on the state senate from 1939 to 1962 after having been Lock Haven's mayor and postmaster. The George B. Stevenson Dam in Sinnemahoning State Park is named after him, and he is known for his flood control efforts. (Courtesy of the Annie Halenbake Ross Library.)

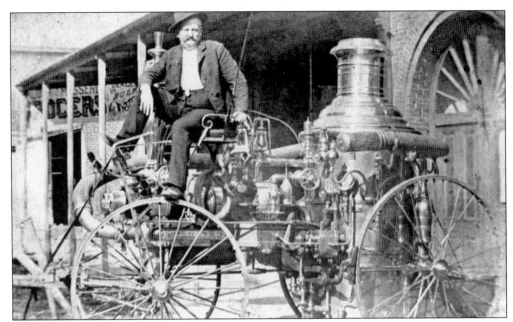

Robert H. McGhee, considered to be the father of Lock Haven fire companies, is seen astride a fire truck as it looked in the days when such machinery used horses rather than horsepower. McGhee is perched on an early fire truck known as the Cataract steamer. He worked for the Cataract Steam Fire Engine Company for 30 years and is known as the founder of the Lock Haven Fire Department. He died in April 1915. (Courtesy of the Annie Halenbake Ross Library.)

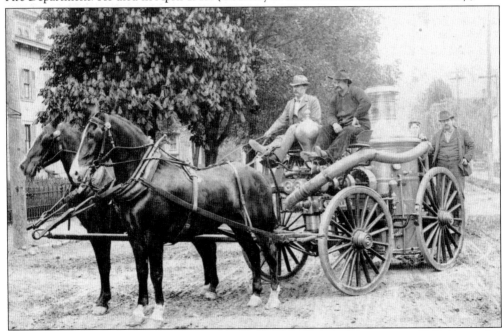

Lock Haven Hope Hose Fire Company's horse-drawn steam engine is seen in 1901. Steam fire engines consisted of a steam boiler and an engine, with the engine driving the pump. Not all firefighters welcomed steam engines as they believed there was an art to hand pump apparatus. (Courtesy of the Annie Halenbake Ross Library.)

Robert H. McGhee is seen again in this 1910 photograph with the Hope Hose Fire Company on Grove Street in Lock Haven. McGhee, also known as "Uncle Bob," is in the center of the photograph. The city of Lock Haven currently has three fire companies, comprised mainly of volunteers. They are the Citizens, Hand In Hand, and Hope Hose Companies. (Courtesy of the Annie Halenbake Ross Library.)

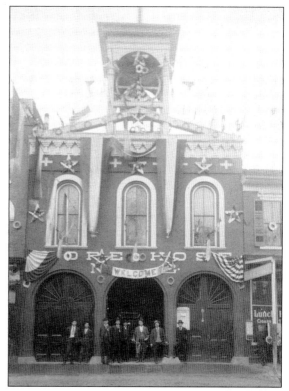

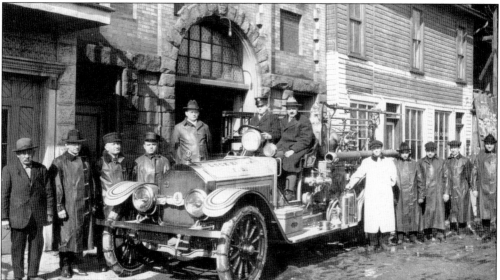

Hand In Hand Hose Fire Company of Lock Haven shows off some fire apparatus. In this 1914 photograph, the volunteer firemen of the First Ward wore their rubber coats as they gathered around their new motor-driven fire truck. The men in the picture, starting at left, include ? Marhoff, Hop Ardner, Tom Caprio, and Charles Basinger in the group standing on the sidewalk in back of the truck. Doll Barrett is at the wheel with Dr. J. S. Mader seated in the truck. The group at right includes Chief John McCollum in a white coat, John Travino, Charles Hall, and Wes Maggs. (Courtesy of the Annie Halenbake Ross Library.)

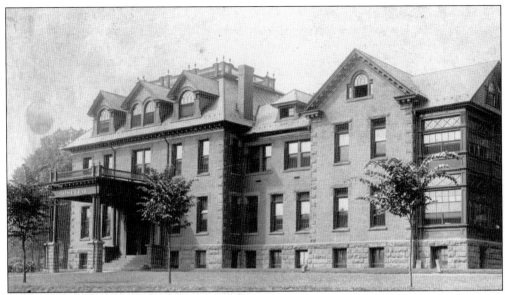

Lock Haven Hospital is seen before and after a fire destroyed it on July 28, 1908. The cause of the blaze was not known, and immediately after the fire, the Central State Normal School gave up girls' dormitory rooms to house the patients. Over 30 patients were removed from the burning hospital on Susquehanna Avenue and taken to the normal school. Damage in 1908 was estimated at $50,000. (Courtesy of the Annie Halenbake Ross Library.)

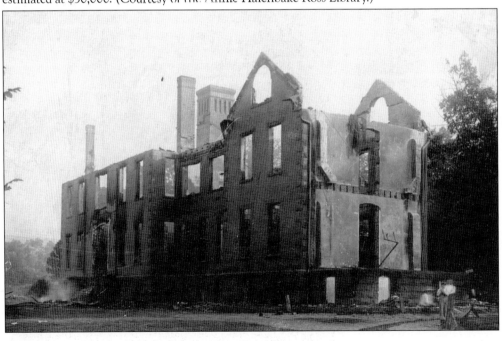

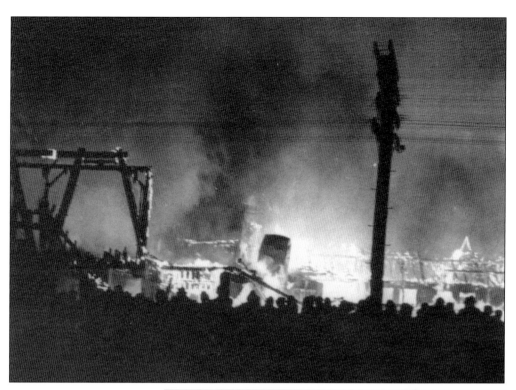

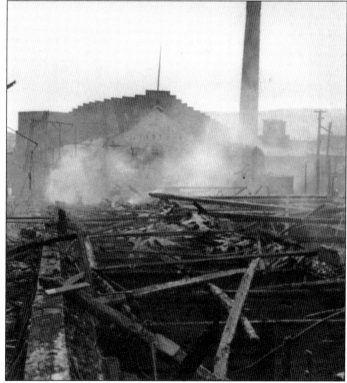

The West Branch Tannery burned on February 28, 1941, and over 100 firemen from five different fire companies were on the scene from 9:30 p.m. until noon the following day. According to the *Lock Haven Express*, "fire finished the work started by depression and cheaper methods, cremated the body of what was once an active Lock Haven industry, the pride of the late Wilson Kistler." The cause of the fire was unknown, and at the time, Max Herr from Centre Hall and Aaron Staimon from Williamsport owned the building, which they had just purchased for $10,000. (Courtesy of the Annie Halenbake Ross Library.)

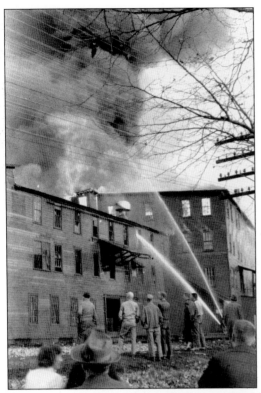

The R. K. Griffin Company factory on West Church Street, Lock Haven, burned in November 1956. Twelve fire companies helped fight the blaze that was caused by a faulty lightbulb socket. The fire was accelerated by lacquer from the chair company, ignited in the second floor. Train service was held up in order to give firefighters adequate working space to knock down the blaze. Estimated damage to the factory was $500,000 at the time. (Courtesy of the Annie Halenbake Ross Library.)

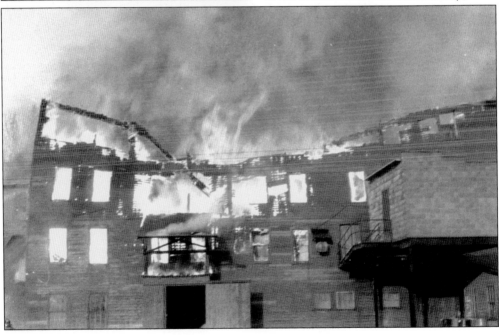

Six
Untamed Susquehanna

Living along the Susquehanna River has allowed the residents of Clinton County to prosper, with the river serving to transport lumber to nearby Williamsport or to local mills. The river also has given beauty to the region and serves as a source of recreation for those who love boating, fishing, camping, and swimming.

But living along the Susquehanna has its drawbacks as the river, at times, has risen beyond its banks and flooded the streets, homes, and businesses in the area. Some of the major floods captured in the area's photographic collections occurred in 1889, 1918, 1936, and 1972. The floods almost seem to have their own personalities. The great flood of 1889 is largely responsible for the end of the lumber era. The ice flood of 1918 hit the county with a cold wrath that froze the streets of Lock Haven. The St. Patrick's Day flood of 1936 entirely obliterated the Great Island. And many can still recall the flood that occurred in June 1972 when Hurricane Agnes was responsible for 48 deaths in Pennsylvania and over $2.1 billion in damage in the commonwealth, according to the National Weather Service.

It was Agnes that sent civil engineers into motion to try to definitively solve Lock Haven's flooding problems, although earlier attempts had been made. In the early 1990s, Lock Haven would install a levee system that would serve to protect the city in 2004 when Hurricane Ivan caused the Susquehanna and its tributaries to overflow. Where Lock Haven escaped the deluge, other low-lying areas along the Susquehanna River were still affected by Hurricane Ivan, and floods still remain an occasional threat for many of the residents of Clinton County.

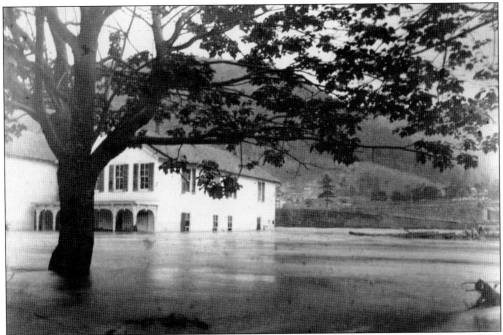

The residence of Isaac Gates of Renovo is seen in both photographs, during and after the flood of May 30, 1889. The 1889 flood was known as the "great flood," and it not only hit Lock Haven, but surrounding towns like Renovo. Lock Haven became a staging point for aid for many of the other towns, as it was during the 1936 flood. But for Renovo in 1936, seven bombers from Langley Field in Virginia dropped bread and iron rations as 400 families were left homeless. (Courtesy of the Clinton County Historical Society.)

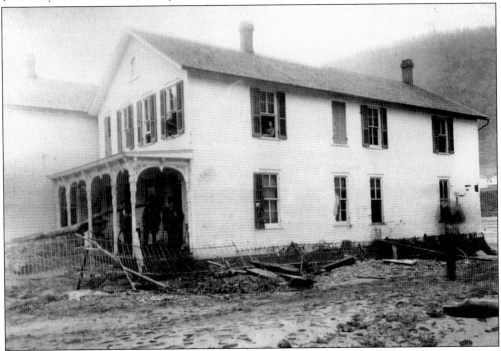

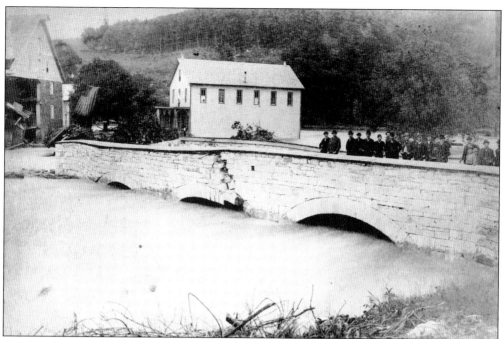

People stand on a broken stone bridge in Mill Hall in the photograph above during the 1889 flood as water continues to sweep through underneath. The residence in the back is still surrounded by water, and the structure at left has begun to fall down. Initial death reports for the flood in Lock Haven mentioned one life, but several lives were believed to be lost in Mill Hall. In the photograph below, taken on June 1, 1889, the residence of Mary Best of Salona is seen entirely removed from its foundation. (Courtesy of the Clinton County Historical Society and the Annie Halenbake Ross Library.)

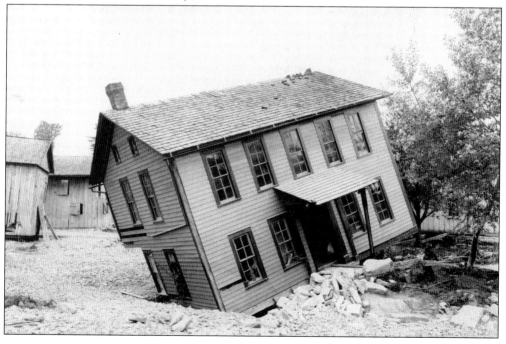

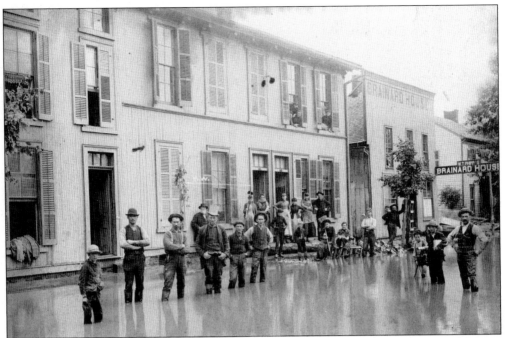

People stand in receding floodwater in front of the Smales residence on Jay Street in Lock Haven on June 1, 1889. The photographer had superimposed a high water mark on the photograph, which is verified in the third doorway from the left as a water stain appears there. Newspaper accounts detail that Lock Haven was 10 feet underwater at its highest points. (Courtesy of the Annie Halenbake Ross Library.)

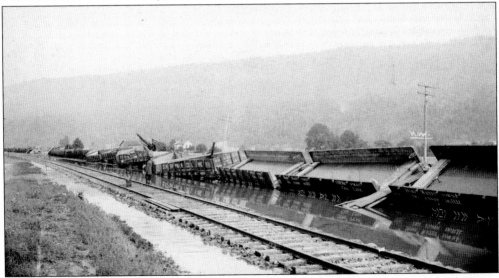

A derailed train is seen in the lower yard of the Pennsylvania and Erie Railroad in Lock Haven on June 1, 1889, in this J. W. C. Floyd photograph. This was the flood that wiped out the 73-mile stretch of canal from Bellefonte to Northumberland. All of the lumber in Lock Haven was swept away, and according to one newspaper, it meant "the most intense suffering on the part of thousands of idle men" that summer as Lock Haven lost its grip on the eastern lumber markets. (Courtesy of the Annie Halenbake Ross Library.)

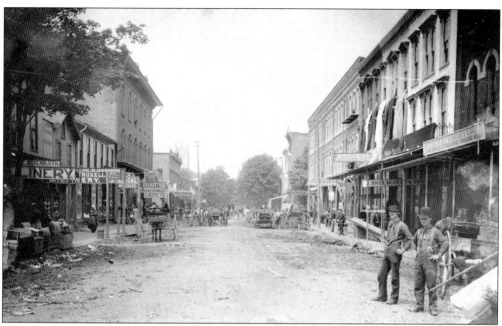

Residents in Lock Haven clean up East Main Street in 1889 in the photograph above taken by J. W. C. Floyd. In the photograph below, people standing in water are prepared to start cleaning outside the Jacob Brown and Son "Old Reliable Grocery" store on East Main Street. The city of Lock Haven made a resolution calling for assistance from across the United States. It stated, "There was not a square inch of land within the corporate limits of the city proper that was not submerged, and when the water subsided it left a layer of mud and filth which, under the strong sun, creates a stench almost unbearable. The contents of vaults and cesspools are in our cellars and on our main thoroughfare and nothing will save us from a frightful epidemic unless help comes promptly and generously." (Courtesy of the Annie Halenbake Ross Library.)

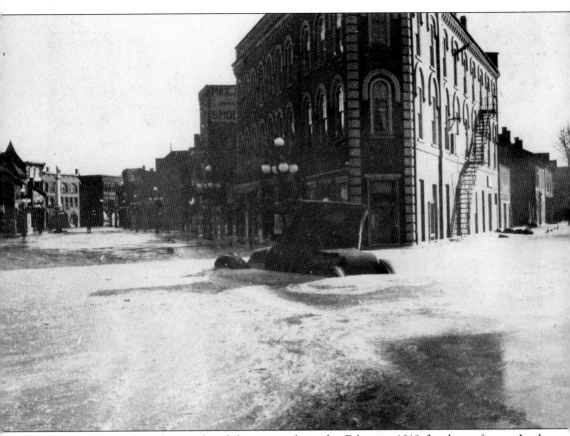

The owner of the submerged and frozen car from the February 1918 flood was former Lock Haven mayor Clarence Dunn. The mayor abandoned the car to rising water. Water filled the streets of Lock Haven and froze solid. The scene shows the "flatiron" building at the intersection of Bellefonte Avenue and Church Street, known at the time as the "five-way light." (Courtesy of the Annie Halenbake Ross Library.)

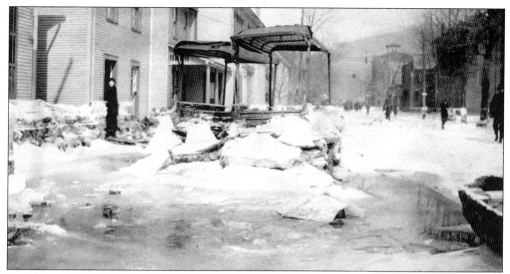

Lock Haven Express delivery wagons are surrounded by chunks of ice on Vesper Street in Lock Haven in the above 1918 photograph. Below, River Road is covered by chunks of ice looking toward McElhattan. This flood was known as the "ice flood," which began on February 13, 1918. Ice had piled up in the Susquehanna River between Lock Haven and Jersey Shore, and a short period of warm weather with rain on February 18 and 19 caused the river to flood the streets, stores, and houses of Lock Haven. "A cold wave with zero temperature on the night of the 20th caused the water in the houses to freeze to a thickness sufficient to permit people to skate on it," the *Monthly Weather Review* journal of February 1889 reported. (Courtesy of the Annie Halenbake Ross Library.)

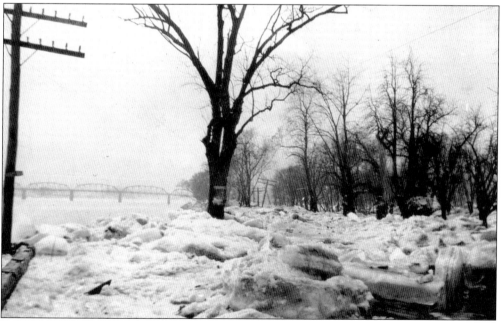

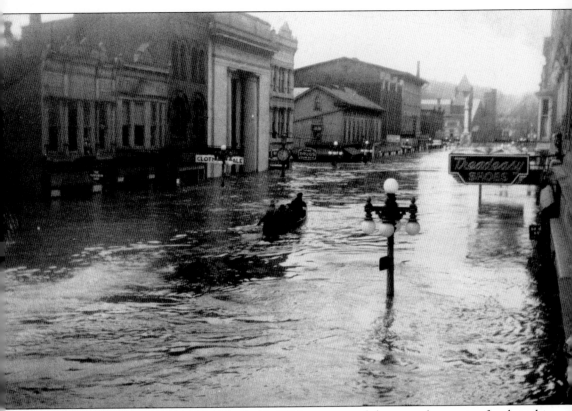

The St. Patrick's Day flood of March 18, 1936, was one of the most destructive floods to hit the towns along the West Branch of the Susquehanna. The water level in Lock Haven rose to 32.3 feet above the bottom of the river. Downtown Lock Haven's Main Street literally became part of the river. St. Paul's Episcopal Church also was destroyed during the flood by fire. (Courtesy of the Annie Halenbake Ross Library.)

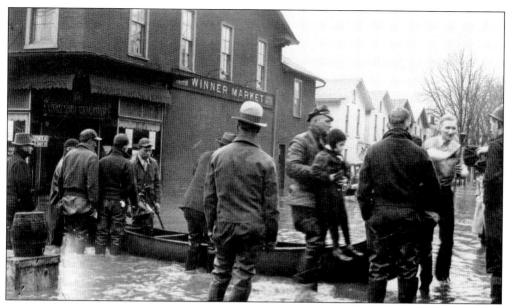

Rescuers unload a boat of residents at the flooded intersection of Bellefonte Avenue and Jones Street in Lock Haven in the above photograph in 1936. Below, a firehouse in Mill Hall is surrounded by water, as even the people who were conducting rescue operations were victims of flooding as well. Initial reports that reached national news outlets noted that six people had died in the flood and that telephone service was not working for much of the area. By March 19, reports stated that 10 lives had been lost in the Lock Haven area. (Courtesy of the Annie Halenbake Ross Library.)

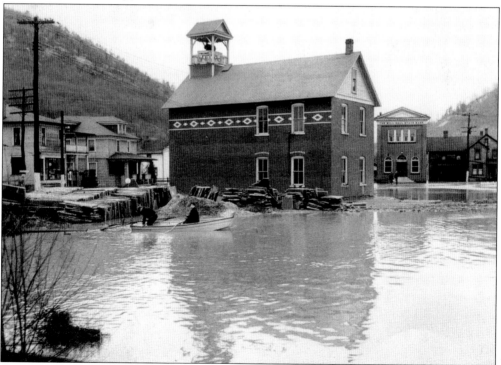

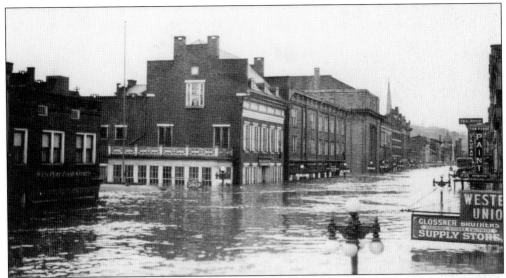

A view of Lock Haven's East Main Street, looking west, is seen in 1936 in the above photograph with water nearly reaching the signs of the stores, much higher than the initial reports of water reaching six feet above street level. In the photograph below, a boat passes through the intersection of Jay and Main Streets in Lock Haven. The Pennsylvania National Guard declared martial law. (Courtesy of the Annie Halenbake Ross Library.)

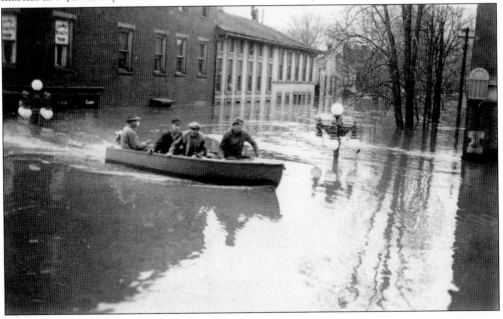

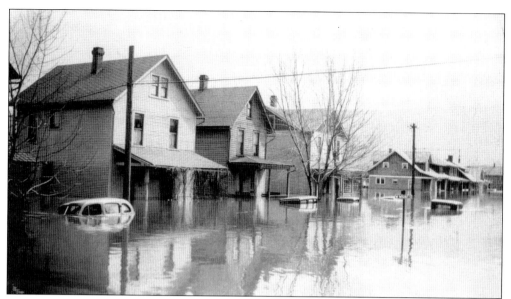

Houses along South Jones and Walnut Streets in Lock Haven are seen underwater in the above photograph in 1936. Below, a crowd of spectators gathers to see the condition of the city of Lock Haven looking northeast over Bellefonte Avenue. Newspaper reports claimed that around 200 people wound up jammed into four rooms on the second floor of one of the city's schools that was hit by the flood, and the only "facility" was a drinking fountain. Food and supplies were sent there by the American Red Cross. (Courtesy of the Annie Halenbake Ross Library.)

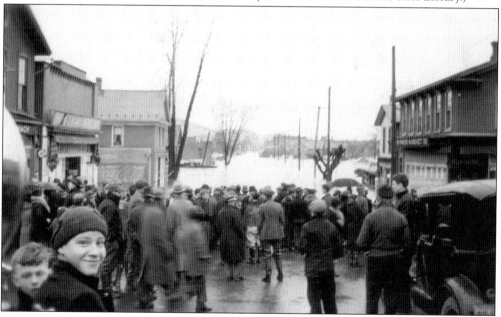

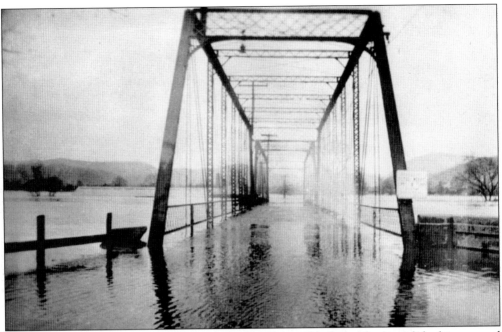

The Castanea Bridge was engulfed by water as it is seen in the above photograph looking toward Lock Haven on March 18, 1936. Below, Lusk Run Road is seen underwater. On March 17, media reports said that both the Susquehanna River and Bald Eagle Creek rose at a rate of three to four inches an hour at first. In the first 24 hours of the flooding, the Susquehanna River rose 5.4 feet. (Courtesy of the Annie Halenbake Ross Library.)

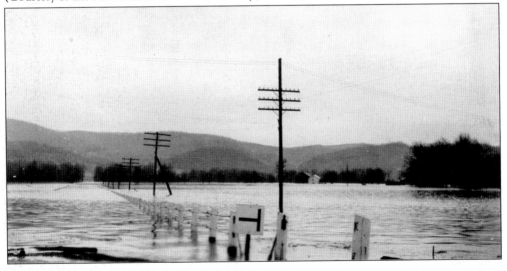

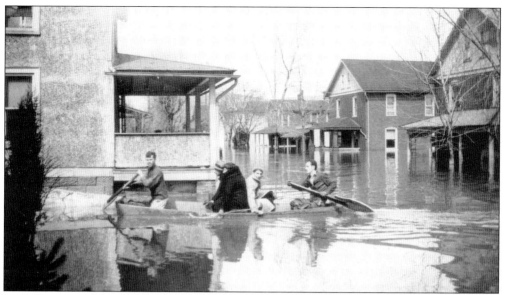

Lock Haven residents paddle down James Street in 1936 with homemade paddles in the above photograph. Five people are riding in a boat that is precariously close to the level of the water. In the photograph below, a young boy walks in water on a submerged sidewalk next to waterlogged automobiles on South Jones Street in Lock Haven. There were reports of a shortage of fresh water and food in the city. (Courtesy of the Annie Halenbake Ross Library.)

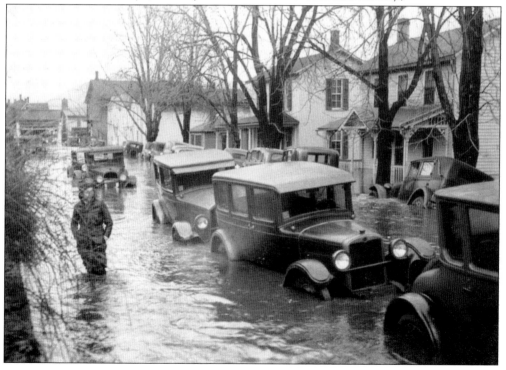

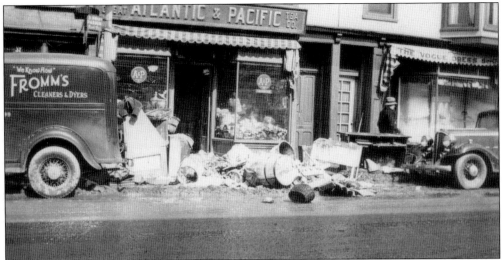

Debris lines the streets of Lock Haven, seen in the above photograph of Bellefonte Avenue and the photograph below of East Main Street, as residents and business owners work to clean up after the 1936 flood. The mud, seen clearly in the lower photograph, was inside many of the buildings and homes, and residents used shovels to scoop it out. The American Red Cross sent a detail of volunteers to help with flood cleanup efforts, and a medical detachment arrived to help monitor and treat community health problems. (Courtesy of the Annie Halenbake Ross Library.)

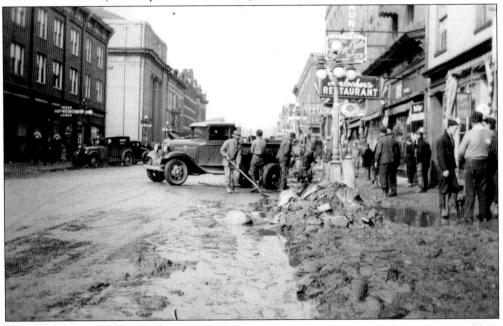

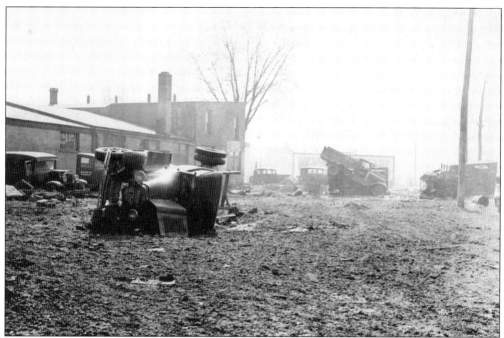

Clarence Moore's Garage in Lock Haven, seen in the above photograph, suffered severe damage in 1936 as the automobiles there were strewn about by the floodwaters. Perhaps one of the hardest hit areas was the Great Island, with the first bridge to the island seen in the lower photograph. Houses and businesses on the island were reduced to rubble. (Courtesy of the Annie Halenbake Ross Library.)

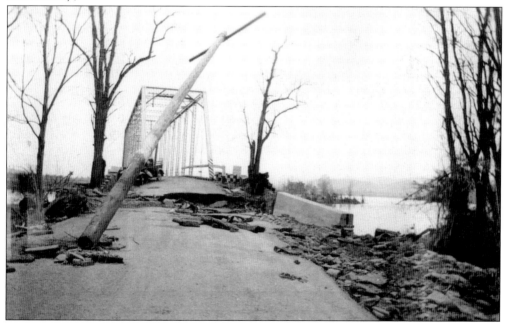

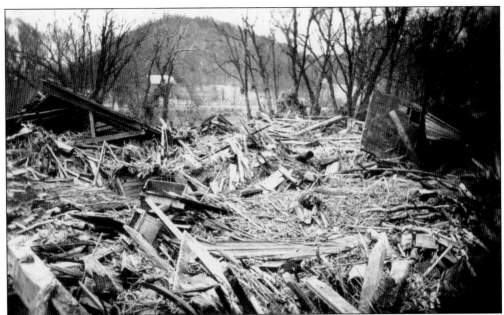

It looks as if a bomb went off in the upper and lower photographs of the Great Island area, as debris was mostly what remained after the 1936 flood. In the photograph below, a house on the Great Island is on its side after it was picked up by the floodwaters. The Great Island, the location of the first pioneer settlement in Clinton County, is in a low-lying area and has always been susceptible to being hit hard by flooding. Reports from the 1889 flood about the Great Island said that after the flood, the train tracks were reported to be underneath three feet of thick mud. (Courtesy of the Annie Halenbake Ross Library.)

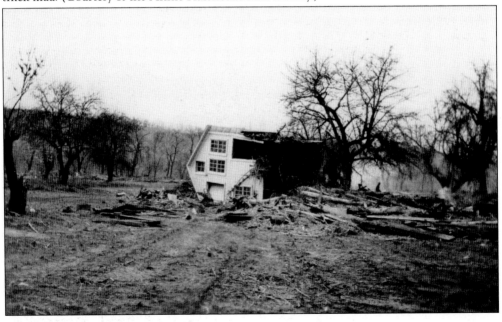

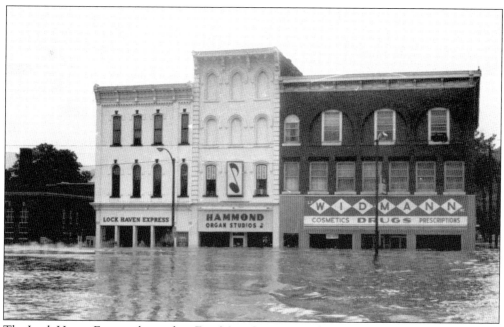

The Lock Haven Express, located on East Main Street in Lock Haven, is seen underwater during the June 1972 flood caused by Hurricane Agnes in the above photograph. The newspaper was hit hard during both the 1936 and 1972 floods. In 1936, no current editions, even the one from the day before that flood hit, could be found after the water receded. In 1972, the paper, along with other newspapers in Pennsylvania that were affected by flooding, was not able to get out an edition immediately after sustaining damage. One newspaper quipped that it had three times the supply of newspaper than it did before the flood due to the paper absorbing water and expanding. In the photograph below, St. Agnes Catholic Church in Lock Haven is seen underwater. (Courtesy of the Annie Halenbake Ross Library.)

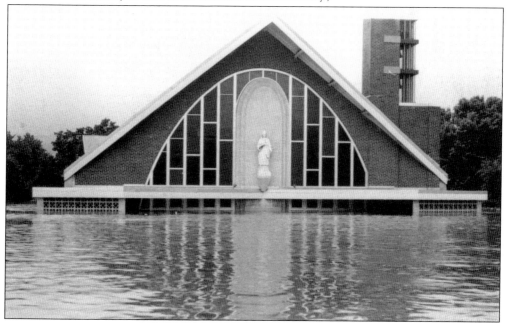

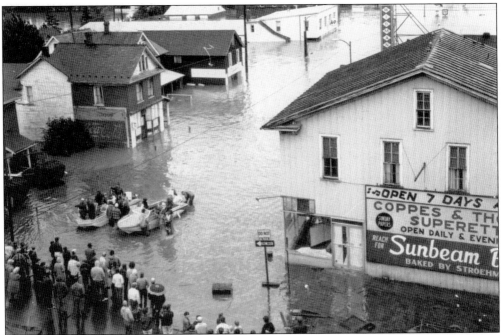

Rescue boats in the above photograph conduct operations at the base of Bellefonte Avenue in Lock Haven in 1972 in front of a crowd of spectators. Below, a boat navigates its way through the city buildings. People were displaced across the state of Pennsylvania, with evacuations seen in 46 counties. The state's Civil Defense Council estimated 250,000 people were evacuated. (Courtesy of the Annie Halenbake Ross Library.)

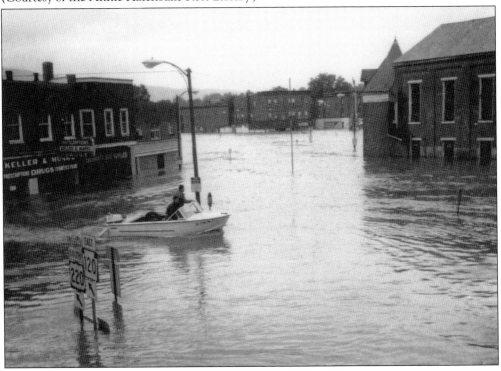

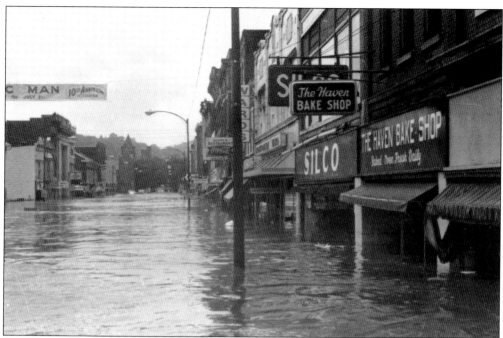

Main Street of Lock Haven is seen in these two photographs with familiar storefronts deluged on June 24, 1972. Many of the businesses in the photograph no longer exist today. Lock Haven was sealed off by the Pennsylvania State Police as bridges and roads were washed out and power was cut off. There also was a fear of a possible explosion since two huge gas tanks were ruptured, spilling out 20,000 gallons of gasoline. (Courtesy of the Annie Halenbake Ross Library.)

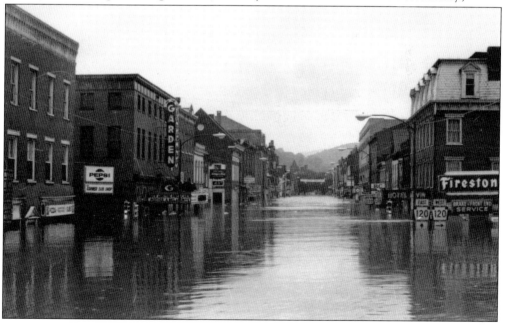

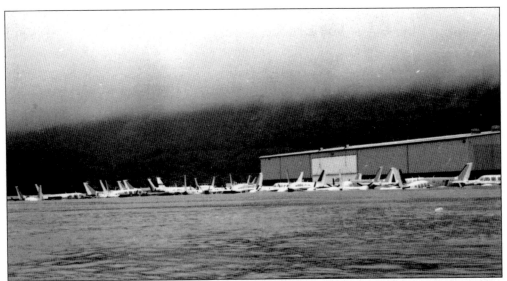

The rains from Hurricane Agnes crippled Piper Aircraft Corporation in 1972, seen in the above photograph, and the company was never able to recover in Lock Haven. Piper was reported to have suffered $23 million in damage. Although Piper received some aid from the government, it was not enough to help the company recover, and operations were eventually moved to a Florida facility. Hammermill Paper also was affected by the floodwaters and had to shut down for a period after the flood. The photograph below shows a second-floor boat rescue on Bald Eagle Street in Lock Haven. (Courtesy of the Annie Halenbake Ross Library.)

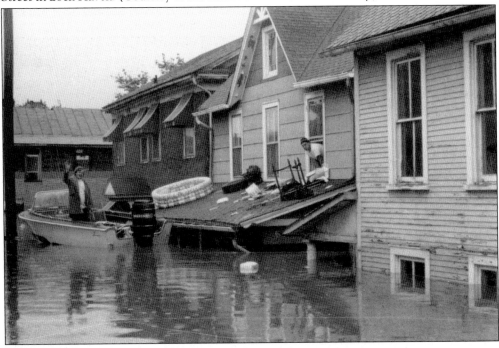

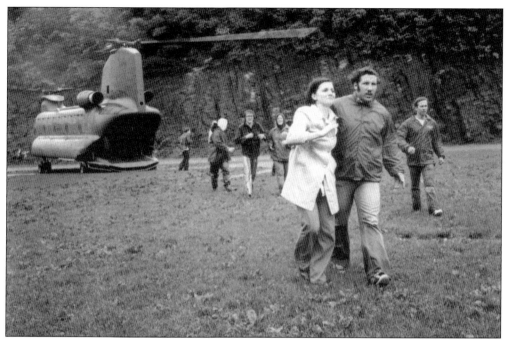

Rescued residents depart from a U.S. Army helicopter that landed on an athletic field at Lock Haven State College, now Lock Haven University. The helicopter was used for rescue operations during the 1972 flood. Below, a road and bridge are completely destroyed on Main Street in Mill Hall. One-third of the area's population was reported as not being able to live in their homes at the time of the flood. (Courtesy of the Annie Halenbake Ross Library.)

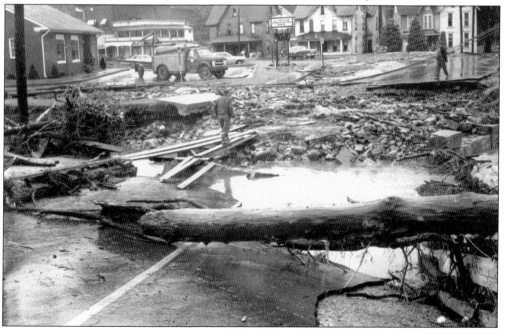

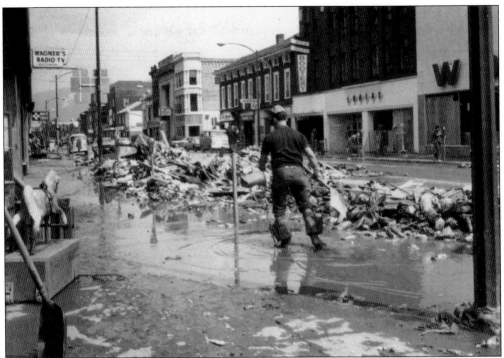

Residents and store owners clean up along a muddy East Main Street in Lock Haven on June 26, 1972. In the above photograph, a man uses a snow shovel to move mud and debris, with a curbside pile almost as tall as he is. Below, a National Guard truck is seen with a municipal dump truck. The business district was reported to be 15 feet underwater. The Susquehanna River at Lock Haven rose to 31 feet, and the flood hit an estimated 100 stores in an eight-block area. (Courtesy of the Annie Halenbake Ross Library.)

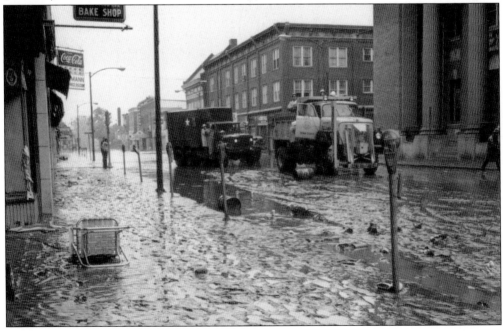

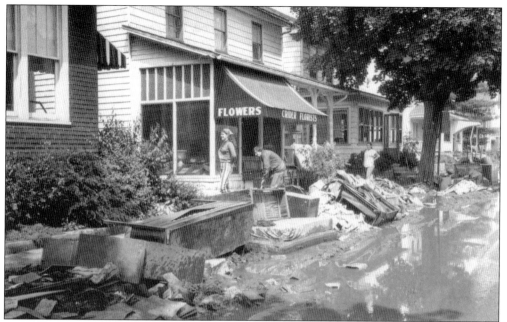

Families in homes along East Main Street in Lock Haven clean out their damaged belongings and line the walks and curbs in June 1972 in the upper photograph. Below, a truck ironically lands upside-down on top of another truck along with other debris. Two emergency trailer courts were set up for homeless families, supplied by HUD (Housing and Urban Development). The county had received 800 applications for emergency shelter. (Courtesy of the Annie Halenbake Ross Library.)

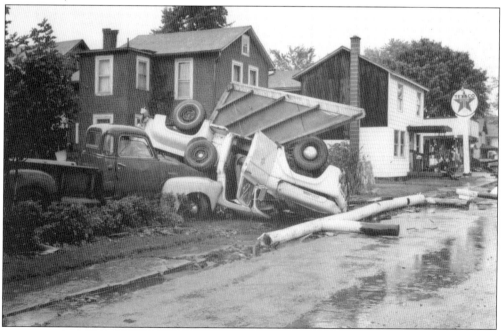

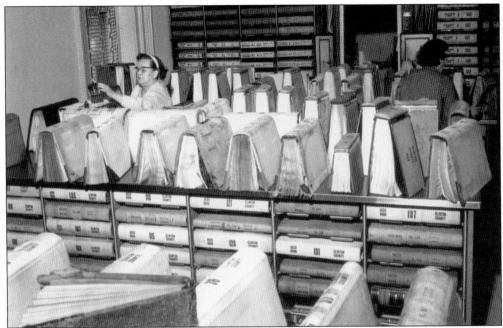

A clerk in the Clinton County Courthouse, located on Water Street in Lock Haven, dries out Clinton County deed books in 1972 in the photograph above. Below, Lock Haven's Robb Elementary School basement library was severely damaged by the flood. The comeback from the 1972 flood was slow in Lock Haven and surrounding communities. A visiting football team from Westminster College that played the Lock Haven State College team in mid-September 1972 reported that a number of storefronts were still boarded and many businesses were not opened. The city worked to boost the morale of merchants for Christmastime by putting out holiday decorations. (Courtesy of the Annie Halenbake Ross Library.)

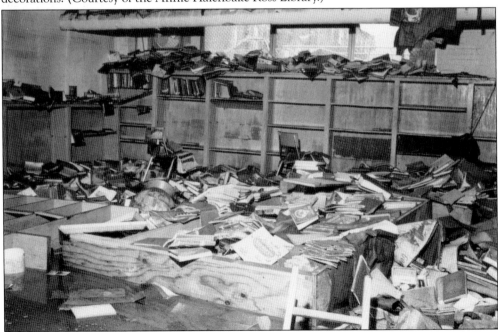

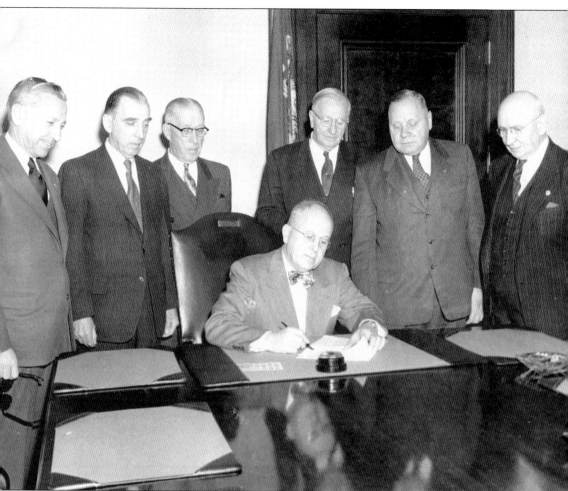

Former Pennsylvania governor John S. Fine signed the General State Authority bill to create the First Fork dam in 1953. A total of $25 million was devoted to flood control under the bill, which created the First Fork dam of Sinnemahoning Creek in Cameron County. That dam, located 28 miles away from Renovo, was to help protect the downstream localities of Renovo, Lock Haven, and Williamsport. The dam is the George B. Stevenson Dam, and Stevenson is the second from the right in the photograph. Stevenson was the mayor of Lock Haven during the 1936 flood and pushed for better flood protection. Unfortunately, the dam would do little to blunt the force of Hurricane Agnes in 1972. (Courtesy of the Annie Halenbake Ross Library.)

Lock Haven was finally able to control the flooding Susquehanna River after completion of a dike-levee system in 1993, as the floodgate installation is seen being finished in the photograph above. Surrounding areas have not been as fortunate, as Hurricane Ivan proceeded to devastate Mill Hall and other local communities in 2004. Lock Haven's levee system also has served other purposes and is the center of recreation and entertainment. Avid walkers and joggers use the levee, and concrete bleachers, seen in the photograph below, are used for riverside entertainment. Today a series of concerts is held on a floating stage in front of the bleachers. (Courtesy of the Annie Halenbake Ross Library.)

Seven
Outside of Work, There Is Play

Clinton County always has been a haven for the lover of the outdoors. Hunting, fishing, boating, camping, and swimming are as popular today as they have been over the years, and residents and visitors alike flock to the great rustic beauty of the area's mountains and to the scenic Susquehanna River for recreational activity.

The different areas of the county have hosted their own beloved events over the years. Lock Haven once was home to popular soapbox derby races that are still talked about to this day by the city's residents. Farrandsville, as it has in the past, still attracts dirt bike riders who enjoy the challenge of the rugged landscape there. And various towns continue to have their own parades and annual celebrations.

Whether it is to engage in a sporting event, celebrate a day of national significance, meet for a charitable purpose, or gather with one's family for an outing, the residents of Clinton County appear to enjoy their free time.

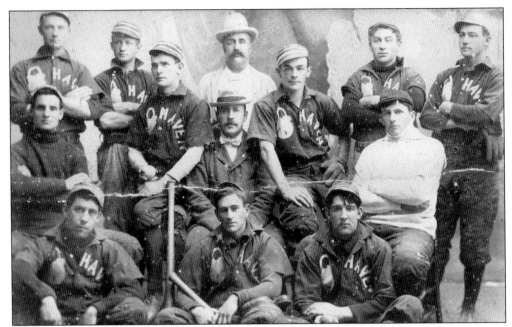

The 1893 Lock Haven baseball team's uniform sports the image of a lock, followed by the word *Haven*. Team members include Pat Horan, ? Gill, George A. Brown, Eddie Lee, Tom Hanna, Frank Gatins, ? Gallagher, Charles H. Myers, ? Morgan, ? O'Brien, Pete Sperlein, Lew Ritter, and unknown. (Courtesy of the Annie Halenbake Ross Library.)

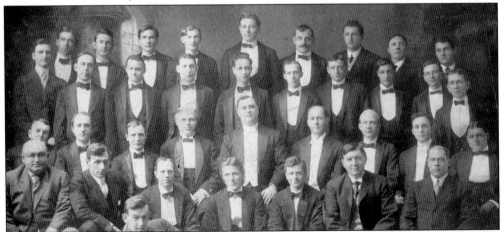

The Hospital Charity Minstrels, pictured here on February 17, 1909, staged annual performances in the Lock Haven Opera House to raise money for improvements and equipment at Lock Haven Hospital. Pictured from left to right are (first row) George W. A. MacDonald, Ernest Ryan, George Kreamer, John A. Law, Earl N. Harnish, Arthur B. Salmon, and Charles F. Strayer. In front is Harry S. Young; (second row) William Peck, Warren M. Smith, David Law, Samuel H. McDonald, Joseph A. Simon, Prof. J. W. Yoder, Frank L. Fox, Ralph Harnish, and Alex J. Widmann; (third row) Edward B. O'Reilly, James H. Krom, Thomas C. Bacon, Fred S. Painter, Milton H. Simon, Clause S. Miller, Nathaniel B. Hanna, Lewis F. Widmann, Harry B. Otway, and Charles E. Herr; (fourth row) Samuel H. Heisey, Edward J. Monaghan, Albert Meckley, Mark Gardner, I. T. Parsons, William G. Voss, W. Brown Elliot, William Blake, and J. Wesley Maggs. (Courtesy of the Annie Halenbake Ross Library.)

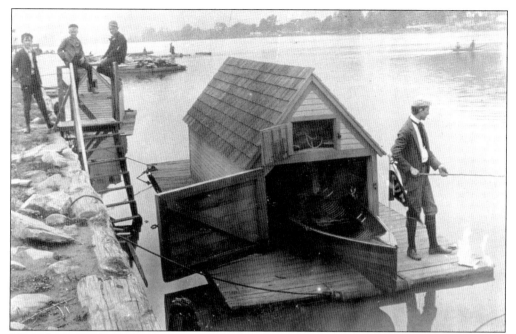

Three boys watch as a man fishes off a small canoe's boathouse on the Susquehanna River near Lock Haven. Fishing along the Susquehanna River in Clinton County has always been a favorite local pastime, as seen in this undated photograph probably taken before 1900. (Courtesy of the Annie Halenbake Ross Library.)

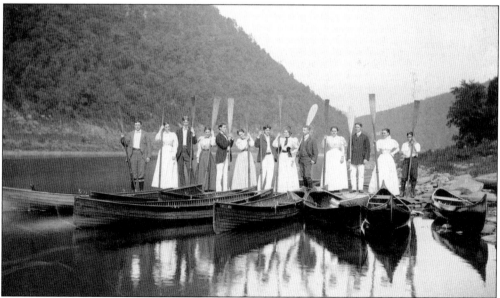

The Lock Haven Boat Club was formed in 1901 and was a popular social organization that was active for many years. This photograph shows a group of individuals getting ready to get into their canoes. The group includes, from left to right, Edward Bridgens, Elizabeth H. Peale, Thomas R. Weymouth, George D. Green, Girard Williamson, Eleanor Salmon, L. P. Salmon, Grace MacVickar, Sedgwick Kistler, Florence Brown, Bruce Hayes, Mary Watson, and Max Hayes. (Courtesy of the Annie Halenbake Ross Library.)

Children play a game where they are walking around in a circle in the photograph above, taken in 1912 at a Lock Haven playground. In the photograph below, children play in a shallow pool at Harmon Playground, located at the east end of Lock Haven in the 1930s. Recreation programs were started at the playgrounds in 1915, and in 1947, the playgrounds were taken over by the city and the school board. A formal recreation board was eventually created to oversee the playgrounds. (Courtesy of the Annie Halenbake Ross Library.)

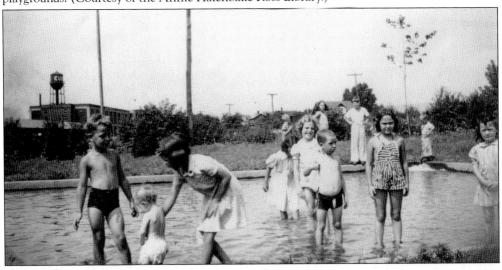

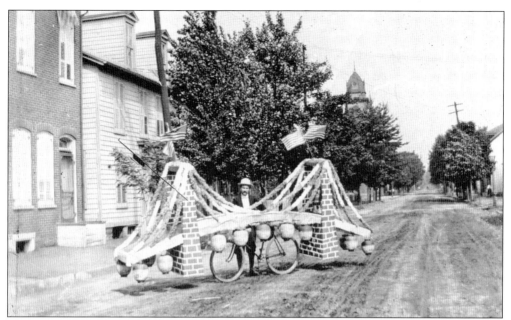

The Brooklyn Bridge on a bicycle, seen here on East Church Street in Lock Haven in the photograph above, was a prizewinner in an 1898 parade hosted by the Lock Haven Cycle Club. The photograph below features the club itself. According to a newspaper report at the time, "Some of the finest decorated wheels were Al Rote, revolving umbrella; Charles Hamilton, air ship; Miss Annie Bickford, umbrella; Annie Freed, square float with arched top; L. H. Miller, Brooklyn Bridge; Miss Ruth Schulyer, George Forbes and Nevin Derr." (Courtesy of the Annie Halenbake Ross Library.)

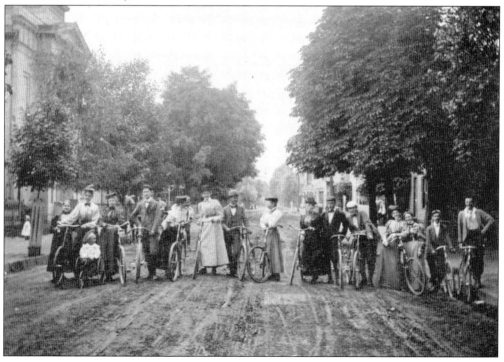

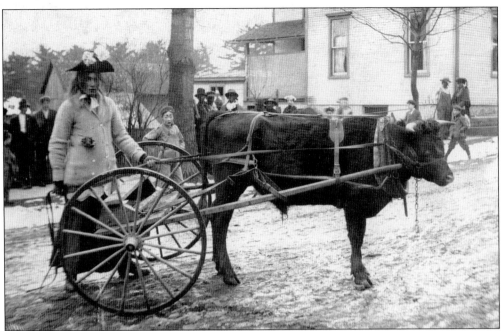

Harry Kemmerer kicked off 1913 with a bit of whimsy in Loganton, as can be seen in these photographs of the New Year's parade held there. In the above photograph, Kemmerer wears a wig and a woman's dress, hat, and sweater. He is driving a cart driven by a cow. The photograph below shows clowns at the Kemmerer farm as Kemmerer sits astride a mule playing a guitar. Yoked next to the mule is a cow, and they are set to pull along a sled carrying two clowns. (Courtesy of the Annie Halenbake Ross Library.)

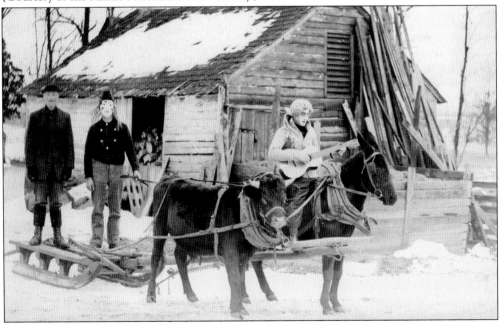

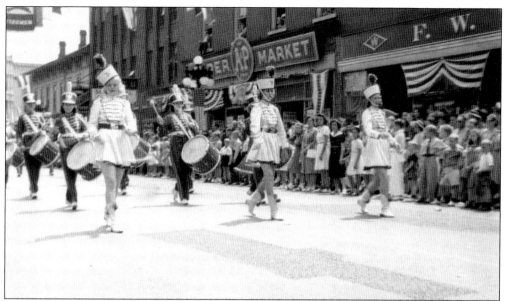

Majorettes and a band walk in front of the A&P market on Main Street, Lock Haven, in the above photograph of the 1939 firemen's parade. The photograph at right of the same parade shows members of one of the city's fire companies waving at the crowd. Clinton County is known for having a strong volunteer fire force as well as a supportive public, and firemen's parades have been held throughout the years. A large parade was held in August 1972 when Lock Haven hosted the Central District Volunteer Firemen's Association annual convention. Some 3,000 volunteer firefighters with 200 units were reported to have attended the parade. (Courtesy of the Annie Halenbake Ross Library.)

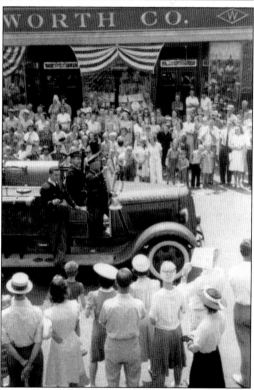

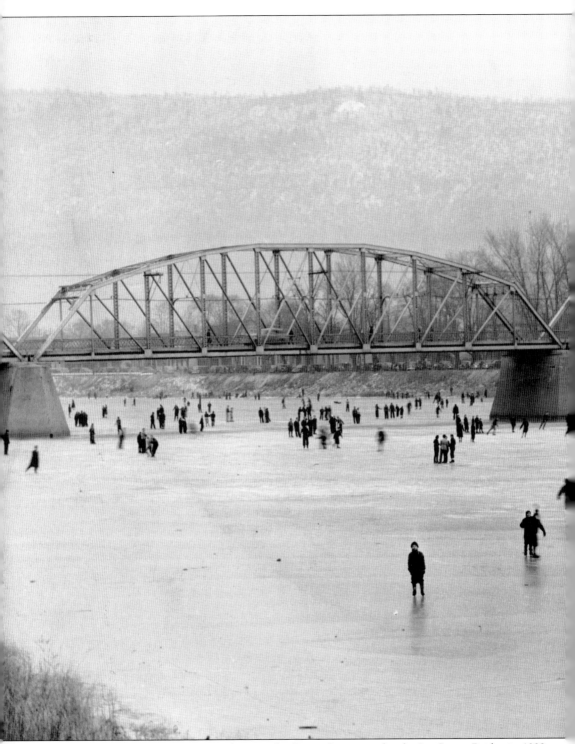

The community comes out to ice-skate on the Susquehanna under the Jay Street Bridge in 1939. This is a rare photograph, as the West Branch of the Susquehanna River rarely freezes. But 1939 saw a very cold winter, as the *Gazette and Bulletin* in nearby Williamsport headlined a story on

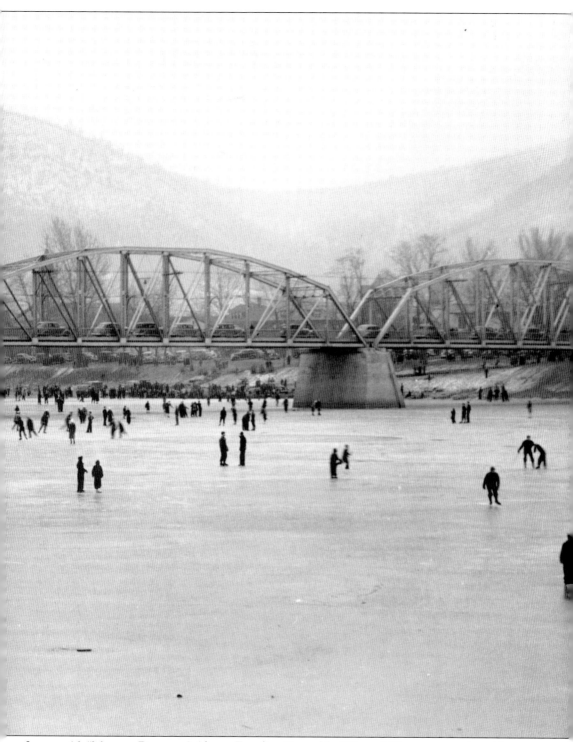

January 16, "Mercury Drops to 3 Above, Equaling Record for Winter." The story mentioned how certain areas along the river were being used for skating as even colder weather was on its way. (Courtesy of the Annie Halenbake Ross Library.)

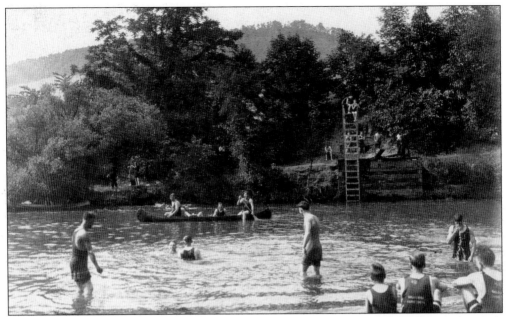

Bathers enjoy an afternoon at Bald Eagle Creek some 600 feet above the dam in 1920. People enjoy canoeing left of center in the photograph, and in the rear, on the other side of the creek, someone prepares to go off of a diving board. Clinton County has no shortage of swimming and boating areas and is the home of rivers, streams, and creeks. (Courtesy of the Annie Halenbake Ross Library.)

Philip A. Zindel, who built Zindel's Rock Garden park, fishes at McElhattan Dam. The area is now the protected reservoir for Lock Haven, known as Keller Reservoir. The city of Lock Haven owns 2,500 acres at the site of the reservoir. (Courtesy Annie Halenbake Ross Library.)

Riders brave the steep Meadow Hollow Motorcycle Climb in Farrandsville in 1949. One bystander has an ideal view of the activities by sitting in a tree. Although virtually all business and industry has left Farrandsville, it still is a popular place for motorcycle racing and is now the home of the Durty Dabbers, a group of local motorcycle enthusiasts. (Courtesy of the Clinton County Historical Society.)

Zindel's Rock Garden park, built by Philip A. Zindel, was a popular stop for tourists in McElhattan and featured water works and small gardens. The site is now where the Keller Reservoir property is located. A postcard notes that the park had a lava house made from lava from the Mount Edna volcano in Italy. (Courtesy of the Annie Halenbake Ross Library.)

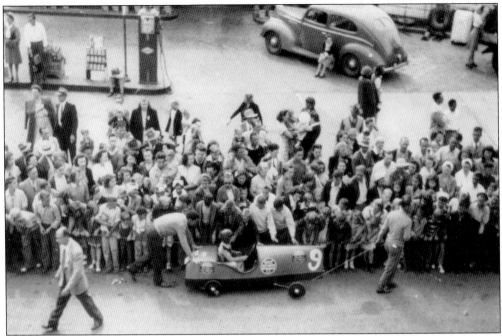

Soapbox derbies rose to popularity in Lock Haven in the 1950s. The steep Bellefonte Avenue in Lock Haven was ideal for soapbox races. Winners had a chance to compete at higher levels—the highest being the All-American Soap Box Derby in Akron, Ohio. The gravity-powered soapbox derby racing craze began close to Akron in Dayton, Ohio, in 1933. In the photograph above, a crowd of mostly young children greets one of the racers as he is pulled in his car in Lock Haven. In the photograph below, an awards ceremony is held in the city after a day of racing. (Courtesy of the Annie Halenbake Ross Library.)

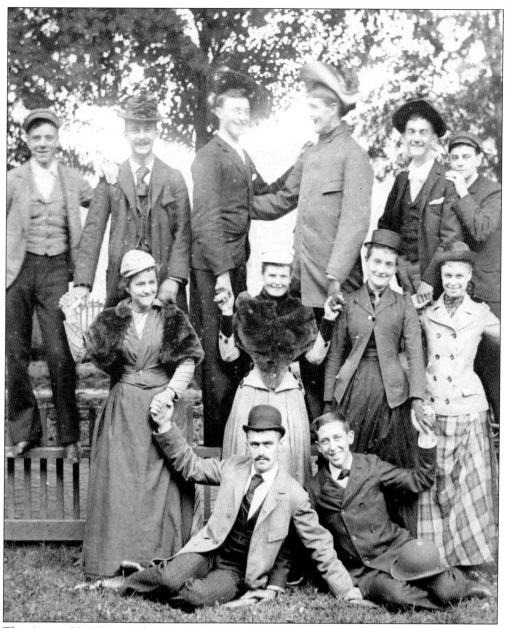

This August 26, 1890, social outing in Lock Haven shows men wearing women's hats, and women wearing men's hats. The outdoor recreation areas in Clinton County serve today as social places for family picnics and outings with friends. People identified in the photograph are Bruce Hays, Jean Furst, Grafius Petrikin, Smith Ferguson, J. Grafius, Max Hays, May W. Sherrick, Bess Ball, Nan Smith, Margaret Harrison, B. Rush Petrikin, and Will Bernard. (Courtesy of the Annie Halenbake Ross Library.)

ACROSS AMERICA, PEOPLE ARE DISCOVERING SOMETHING WONDERFUL. THEIR HERITAGE.

Arcadia Publishing is the leading local history publisher in the United States. With more than 3,000 titles in print and hundreds of new titles released every year, Arcadia has extensive specialized experience chronicling the history of communities and celebrating America's hidden stories, bringing to life the people, places, and events from the past. To discover the history of other communities across the nation, please visit:

www.arcadiapublishing.com

Customized search tools allow you to find regional history books about the town where you grew up, the cities where your friends and family live, the town where your parents met, or even that retirement spot you've been dreaming about.